Through a student initiative, three Frankfurt synagogues destroyed in the 1938 Reichspogromnacht (known as Reichskristallnacht or the "Night of Broken Glass") were computerreconstructed in the spring of 1995 by students of the Department Computer Aided Design (CAD) in Architecture at the Darmstadt University of Technology. The reconstruction of these buildings, resulting from studies of the Nazi period, was to serve as an admonishment as well as a memorial. At the same time, the historical architectural importance of the buildings was to be called to mind. Encouraged by the very positive response to the initial project, the decision was made to expand it to include the computer reconstruction of 15 other well-known German synagogues.

The goal, beyond the political aspect, was to create a representative overview and interior impression of the diverse synagogal architecture that, prior to its destruction, existed in Germany.

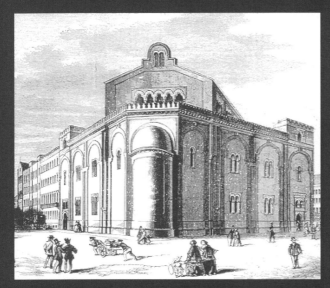

The reconstructed synagogues in Leipzig, Cologne (Glocken-gasse), Kaiserslautern, Nuremberg and Frankfurt/Main (Judengasse) belong to a group built in the neo-Islamic style and were symbolic of the independence of their Jewish congregations. The neo-Islamic and the neo-Romanesque styles were the two most widely used architectural styles for the city synagogues.

top: Leipzig
bottom: Cologne

right page top: Kaiserslautern
bottom left: Nuremberg
bottom right: Frankfurt/Main (Judengasse)

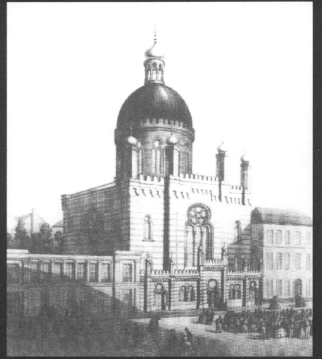

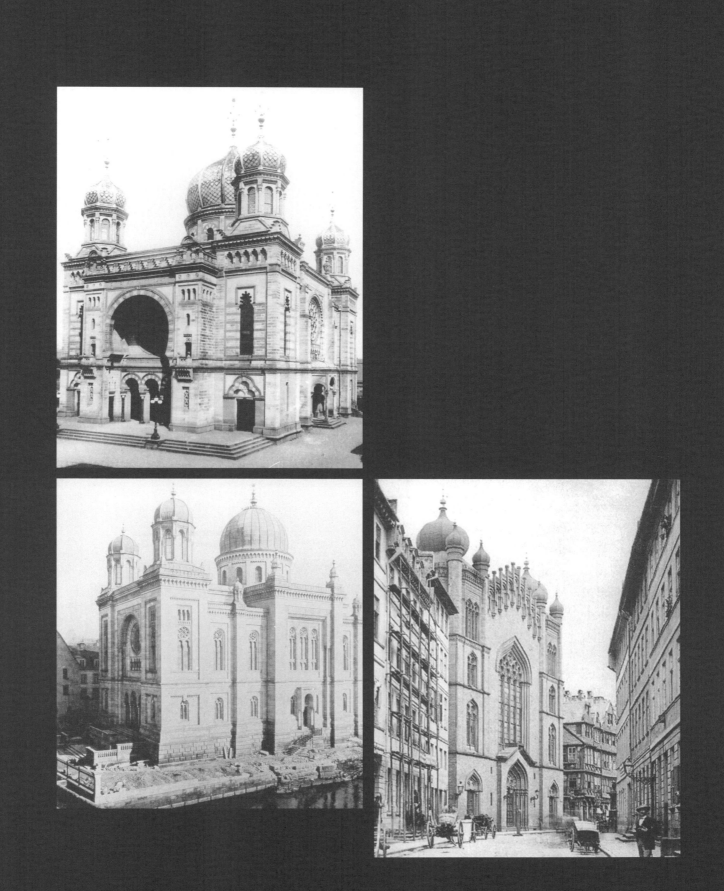

The synagogues in Dresden, Mannheim, Munich and Hanover
were built in the neo-Romanesque style, and share stylistic
elements with famous German Romanesque cathedrals like
Speyer and Worms. This approach was intended to empha-
size Jewish affiliation with the German nation.

The interior of the Hanover synagogue follows the architectural
scheme of orthodox synagogues. In orthodox synagogues
the bimah, from which the Torah (the Five Books of Moses) is
read, is always located in the center of the room.

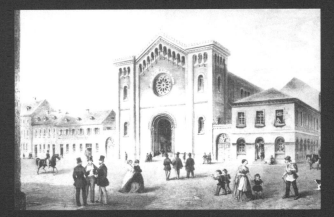

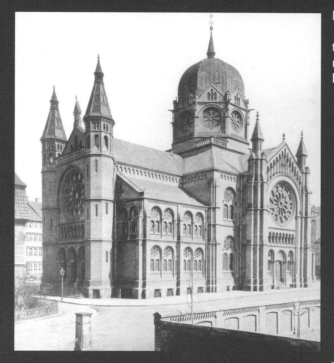

left page: Mannheim

top: Hanover
middle: Dresden
bottom: Munich

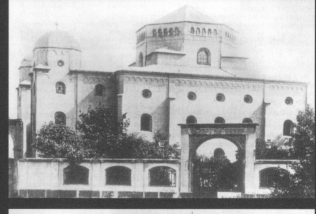

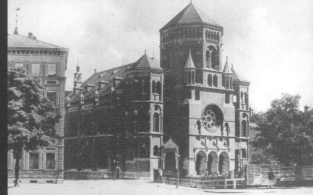

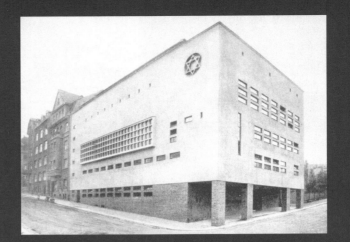

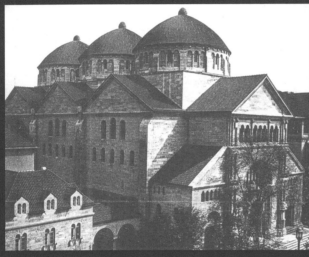

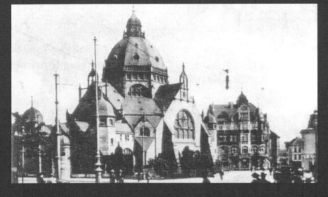

In addition to the synagogues built in the two main architectural styles, German synagogues were also built in contemporary and regional styles. For example, the synagogue in Plauen was built 1930 in the Bauhaus style (New Objectivity, also: International style)

top: Plauen
middle: Berlin
bottom: Dortmund

right page top: Frankfurt/Main (Börneplatz)
bottom: Frankfurt/Main (Friedberger Anlage)

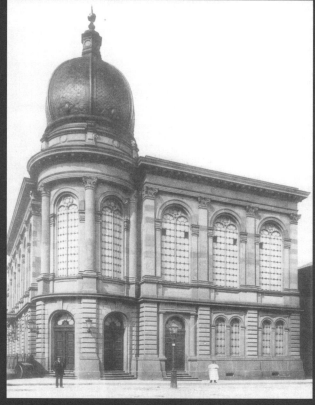

In the 19th and 20th centuries, monumental synagogues were built in almost every German city. Their architectural importance equaled that of Christian sacred architecture. They were part of a shared Jewish and Gentile culture. Examples here include the reconstructed synagogues in Berlin, Dortmund and Frankfurt. In Berlin alone, there were twelve monumental synagogues. One of these was the synagogue in Fasanenstrasse, in which reformed Judaism, founded in the nineteenth century, was practiced. In these synagogues the bimah is placed in close proximity to the Aron ha-Kodesh, an architecturally designed shrine that houses the sacred Torah scrolls.

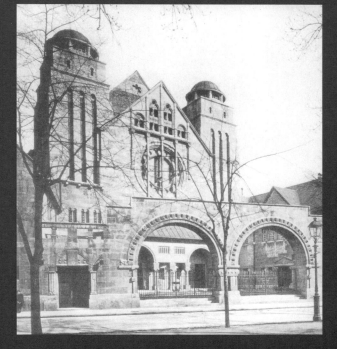

During the Middle Ages, Jews were banned from almost all German cities. It was only after the Enlightenment that Jews were allowed to return to the cities. The Jewish population grew in the 19th century, which meant that many new places of worship were needed. The new social status made it possible to erect prestigious buildings. After 1933 the National Socialists put an end to this development.

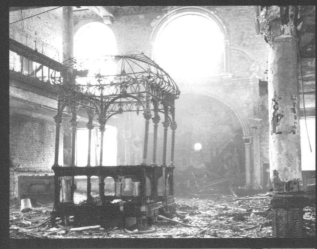

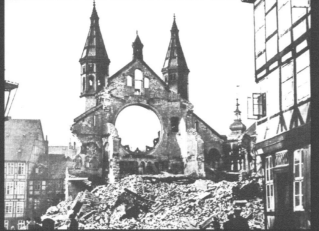

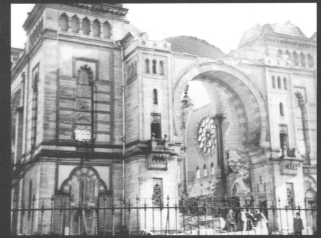

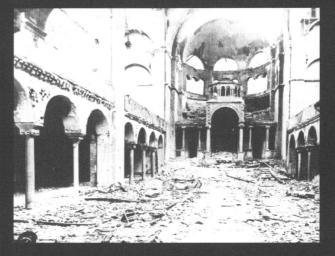

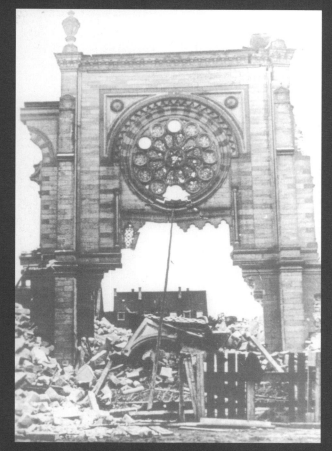

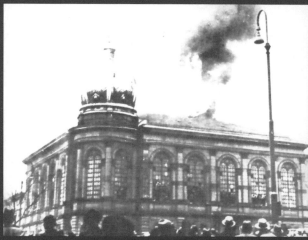

Prior to the Reichspogromnacht of 1938, the National Socialists ordered the destruction of the main synagogue in Munich, as well as the synagogues in Nuremberg, Dortmund and Kaiserslautern. During the Reichspogromnacht and in the days that followed, over 1,400 synagogues and prayer rooms were destroyed or desecrated. Even until today the exact number is not known.

left page top: Nuremberg (Essenweinstrasse)
middle left: Hanover
middle right: Kaiserslautern
bottom: Berlin

top: Kaiserslautern
bottom: Frankfurt / Main (Börneplatz)

Berlin

Dortmund

Dresden

Frankfurt/Main

Hannover

Kaiserslautern

Köln

Edited by
Darmstadt University of Technology, Department CAD in Architecture
Art and Exhibition Hall of the Federal Republic of Germany
Institute for Foreign Cultural Relations

Birkhäuser – Publishers for Architecture
Basel · Boston · Berlin

SYNAGOGUES IN GERMANY A VIRTUAL RECONSTRUCTION

TECHNISCHE
UNIVERSITÄT
DARMSTADT

ART AND EXHIBITION HALL OF THE
FEDERAL REPUBLIC OF GERMANY

i f a ▮ Institut für Auslands-
beziehungen e. V.

With Special Support by:

Cultural Foundation

Deutsche Bank

**DEUTSCHE BANK
AMERICAS FOUNDATION**

Deutsche Bank Group ☑

www.cad.architektur.tu-darmstadt.de
www.synagogen.info
www.bundeskunsthalle.de
www.ifa.de
www.birkhauser.ch

Contents

Preface

The exhibit, "Synagogues in Germany. A Virtual Reconstruction" is the remarkable outcome of a project initiated by students, and realized together with the Department CAD in Architecture of the Darmstadt University of Technology, Germany. To the students this project was a reaction to violent attacks on Jewish institutions in Germany. Shocked by the 1994 arson attack on the synagogue in Lübeck, they began to study the architecture of the 19th and 20th century synagogues in Germany and their changing history. Under the guidance of Manfred Koob and Marc Grellert they gathered an encompassing body of research. The idea was to reconstruct by means of CAD (Computer Aided Design and Construction) the evidence of Jewish culture and architecture in Germany, which had been destroyed systematically and erased from the German cityscape by the National Socialists since the night of the pogroms on November 9, 1938.

Their work of remembrance approaches a heavy chapter of German history. It was clear to everyone that even a perfect virtual reconstruction would not be able to replace what is forever lost. On the one hand the project must be understood as a signal sent by German citizens against the rise of racist, even anti-Jewish ideologies. It is due to such courageous vigilance and determined public opposition as has been shown by the students and teachers in Darmstadt that such resentments no longer find any political resonance in Germany.

Beyond its symbolic effect, the project of virtual reconstruction of synagogues in Germany contributes to the debate about an adequate approach to our historical past, an enlightening approach intelligible to all. Those involved decided to take an unusual and difficult path to fight obliviousness. While many monuments stress what has been destroyed and thus emphasize human suffering or cultural loss, the students and teachers in Darmstadt chose visualization as a more comprehensible language of admonishment, a language also more vulnerable to misunderstandings. Remembering requires knowing what has been lost. Only if what has been lost is visible again it can be wrestled from oblivion.

With the help of the Art- and Exhibition Hall of the Federal Republic of Germany the Darmstadt research project developed into an exhibit. It was shown in Bonn, Germany, from May through October 2000. The Bonn event, supported by the Federal Ministry of Education and Research, numerous communities and private persons, is the foundation of our plan for the foreign stage.

The foreign exhibit has been made possible by the generous support of the Cultural Foundation of Deutsche Bank and Deutsche Bank Americas Foundation. We owe our thanks to the former director of the Cultural Foundation of Deutsche Bank, Walter Homolka, who lent his support for the project from its very beginning. We would also like to thank his colleagues Walter Münch in Frankfurt, Germany, Gary S. Hattem and Rose Bradshaw in New York, USA, for their confidence and their lasting enthusiasm. Thanks also to Salomon Korn from the Central Council of Jews in Germany, who has supported the project in word and deed since its very beginning in 1994.

Since the exhibit in Bonn, Germany, the Department CAD in Architecture of the Darmstadt University of Technology and the Architectura Virtualis have continued to work on the reconstruction. Today, the exhibit centers on 16 synagogues from 14 cities. We thank all students who have participated in the research and design of the project over the years. And in particular we would like to thank Marc Grellert, who directed and guided them with unwavering enthusiasm and knowledge.

Special thanks also to Michael Staab and John Berg for the architecture of the exhibit, which follows the concept of Johann Eisele, Ellen Kloft and Claus Staniek, Department of Design and Architecture of the Darmstadt University of Technology, Miriam Lebok and Michael Bender for the design of the publication on hand, Bernhard Pfletschinger for the documentary film, and Ulrich Best for the supervision of the English dubbing and for providing the film documentation. We would also like to thank Agnieszka Lulinska, the co-curator of the Bonn exhibit, who supervised the project over a long period of time with expertise and perseverance.

The foreign presentation, organized with drive and efficiency by Marie Ani Eskenian, was placed in the hands of the Institute for Foreign Cultural Relations. The exhibit will be part of the intellectual and cultural exchange between the Federal Republic of Germany and abroad.

Ursula Zeller
Institute for Foreign Cultural Relations

Manfred Koob
Darmstadt University of Technology,
Department CAD in Architecture

Wenzel Jacob
Art and Exhibition Hall of the Federal Republic of Germany

Marc Grellert
Architecture as Social Seismograph
Insights into the History of Jewish Religious Architecture

Today the synagogue is considered the specific archi-
tectural expression of the Jewish religion. Histori-
cally, and for a thousand years, another monument
was at the center of the Jewish religion as
its highest religious relic: the antique Temple of
Jerusalem, built by King Solomon in the 10th
century BCE. A special room in this temple, the Holy
of Holies, housed the Ark of the Covenant. This
wooden shrine held the two stone tablets of the Ten
Commandments which, according to the biblical
legend, Moses had received from God on Mount
Sinai. Even though there are no actual pictures
of the Temple of Solomon, its description in the Bible
(1 Kings 6) stimulated several attempts to recon-
struct its appearance. The picture here is one of the
possible interpretations of the biblical text, which
includes exact measurements and even descriptions
of the furnishings. That is how we know that
the temple had, among other things, ten menorahs
(seven-armed candelabra). To this day the
menorah is part of the furnishings of synagogues.

The temple was destroyed in the wake of war in the
year 586 BCE, and the Ark of the Covenant was
stolen. Since then the Ark of the Covenant has been
considered lost. Even though the temple was
reconstructed in the 6th century BCE, the Holy of
Holies remained empty, instead of ten, only one
menorah ornamented the interior. When in the year
20 BCE, King Herod designed the whole temple
district anew, he rang in the last shining period of the
Temple in Jerusalem. In the year 70 CE, after the
Roman victory over the rioting Zealots, the temple
was destroyed a second time, and its furnishings

were taken to Rome. To this day a relief of the Ark of
Titus remembers the fateful events and shows
the raid with the stolen menorah. The Romans were
again victorious in another revolt of the Zealots
in the year 135 CE. This time even the last architec-
tural remains of the temple were destroyed, and
the Jews were banned from Jerusalem. Only part of
the wall around the former temple district still
stands in Jerusalem today, known to many people
as the Western Wall.

Archeological findings have proven that since the
2nd century BCE synagogues other than the
temple existed in antique Palestine. Originally these
buildings were used mostly for non-religious
purposes: congregations, prayer, education and
jurisprudence, and as such were architectural
replications of purely secular buildings. Their style
was borrowed from Roman basilicas. It was only
after the complete destruction of the temple that
these buildings took on predominantly religious
significance as the most important houses of worship.
The cult of the sacrificial offering did not find its
way into the newly established prayer service, which
was centered around the reading of the Torah
(Five Books of Moses). The physical manifestation
of the Torah has changed little through history.
Up to this day the Torah consists of a scroll wrapped
around two heavily ornamented sticks. During
the service the Torah is taken from the Torah shrine
(Hebrew: Aron ha-Kodesh) and brought to the

podium, the bimah. We assume that in the Antiquity,
the Torah shrine as well as the bimah were
portable. Since the Torah scrolls were a congrega-
tion's most valuable possession, a resting
place that was only temporary must have seemed
inappropriate. The search for a permanent shrine
began. Starting in the 6th century CE there are indi-
cations that synagogues had an elevated apse
reserved for the Torah shrine. Following religious
laws which dictated that prayers be directed
towards the former Temple of Jerusalem, the apse
was located at the synagogue wall pointing
towards Jerusalem.. Following this tradition, syna-
gogues in the West were usually pointing East,
and synagogues in the East were usually pointing
West. The destruction of Jerusalem, the enslave-
ment of a major part of the Jewish population, and
the growth of Jewish communities in important
commercial centers in other parts of the world
decreased the significance of Palestine as a
traditional area of Jewish settlement. The last syna-
gogues in what is now modern Israel dates
from the 7th century CE.

The center of Jewish life moved to Europe. Even
though Jews lived in what is now Germany since
the time of Roman settlements, there are no archi-
tectural remains. The oldest architectural evidence
is from the Middle Ages. They were either simple hall
buildings without columns or two-aisled buildings
with two columns (Worms). Men and women were
seated in separate rooms, the women following
the service through openings in the wall. In contrast
to the synagogues of the Antiquity, in an effort to
honor the liturgical center architecturally, the bimah
had its fixed place in the center of the interior
room. Up until the 12th century CE, Jews lived rather
peacefully in most areas, although a wave of

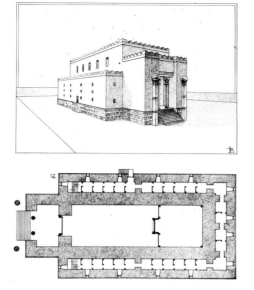

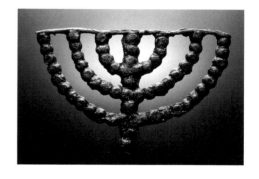

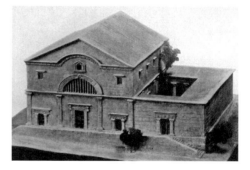

top above: The Temple of Solomon in Jerusalem. View from the Southeast
top below: The Temple of Solomon in Jerusalem. Ground plan
middle: Bronze Menorah found in excavations of Synagogue at Ein Gedi, 6th century CE
bottom left: Ground plan of the synagogue in Kefar Nahum (Kapernaum), 4th century BCE
bottom middle: Ground plan of the synagogue in Beth Alpha, first half of the 6th Century BCE
bottom right: Model of the antique synagogue in Tell Hum

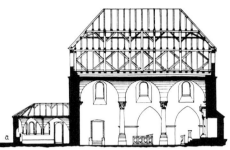

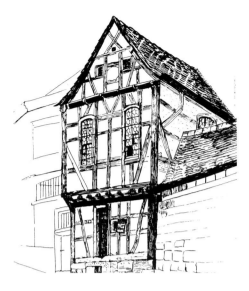

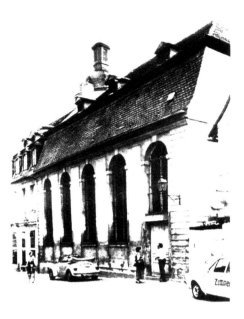

pogroms in the wake of the first crusade in 1096 had destroyed several Jewish communities in the Rhineland. From then on anti-Jewish pogroms, particularly since the church insisted on marginalizing Jews within Christian society. The fact that more and more Jews were involved in commerce and finance – a fact which was, in part, due to a ban on Jews from conducting any trade, and a ban on Christians from conducting any financial business – led to denunciations from Christian debtors. In 1290 the Jews were banned from England, in 1394 from France, and at the end of the 15th century, in the wake of the ban on Arabs, they were forced out of Spain as well. Many fled to Eastern Europe to start communities there. Jews were banned from cites in Germany as well, but unlike in France or Spain, they were allowed to settle in smaller towns and villages. This explains the

largely parochial influence on the architecture of the synagogue at the time. A climate of implicit anti-Semitic sentiment motivated many Jewish communities to build synagogues and sites of prayer that were barely distinguishable from the non-Jewish buildings around them. Only minute details, such as larger windows or a mere hint of a Torah niche in the eastern wall of the building, revealed the true nature of these buildings.

It was not until the Enlightenment that a change occurred in the social status of the Jewish population. At first, synagogues openly articulating their religious nature re-appeared in smaller cities. Growing Jewish social equality made it possible for Jews to return to larger cities as well. In 1798 Friedrich Weinbrenner built the first new synagogue in a larger city, Karlsruhe. Yet the actual sacred room was not obvious in the city's scape. The 19th century was characterized by a large growth in population and, of course, the Jewish percentage grew as well. Consequently, larger houses of

worship were needed. Eventually social conditions were such as to allow the construction of representative synagogues that would be openly recognizable as sacred buildings within the city. In the 19th century Jews themselves could finally become architects and assume numerous construction projects. Commanding buildings, equal in quality to their Christian counterparts, were erected in German cities and became part of a shared culture of Jews and Gentiles.

The synagogues built in Germany up to 1933 can be categorized into three subdivisions: neo-Islamic synagogues of Middle Eastern influence, German Romanesque synagogues, and synagogues following contemporary and local styles. The neo-Islamic expressed the new Jewish self-confidence and

was intended to emphasize their independence.
Gentile architects interpreted this as a charac-
teristic pointing to the roots of the Jewish religion.
Examples are the synagogues in Cologne (Glocken-
gasse), Leipzig, Nuremberg, and Kaiserslautern.

The synagogues that were built in the German
Romanesque style demonstrated the German
Jews' feeling of belonging to the German nation.
Therefore they chose, quite consciously, a style
that had religious connotations, albeit connotations
that circumvented any closeness to the domi-
neering German Gothic. Hence the return to an
architectural tradition reaching back to the first
large German domes such as the Dome of Speyer.
The synagogues of Munich and Hanover, among
others, belong to this group of synagogues.

The third group includes synagogues following con-
temporary or local styles. One example is the
synagogue in Plauen which follows the Bauhaus
style. This group does not show a homogeneous
unity, although subgroups of styles can be detected.
Yet in comparison to the two domineering archi-
tectural styles (which also dominated the intellectual
debate) this last group mirrors the general archi-
tectural situation in all its various manifestations: the
tension inherent between historicism and moder-
nity, a tension that can be detected in any and all
contemporary architectural structures.

Even though the exterior of most synagogues of the
19th and 20th century may lack identifying
characteristics, the interior is almost always defined
by three clearly accentuated architectural elements.

The third element, after the Aron ha-Kodesh and the
bimah, is the women's gallery. Up until the 19th
century the relative placement of these elements was
dictated by orthodox liturgy. It prescribed a place-
ment of the bimah in the center of the interior. This
resulted in a spatial tension between the bimah
in the center of the room – often accentuated by a
central dome – and the Torah shrine in the east,
usually in the most heavily ornamented area of the
synagogue. In contrast to orthodox liturgy, the
liberal liturgy of the 19th century allowed the bimah
to be placed closer to the Torah shrine. The liberal
synagogues therefore are mostly longitudinal.
In summary it can be stated that the synagogue is
not characterized by its exterior. It is, instead,
defined by its interior. Yet the exterior of synagogues
outside of Israel tell the story of the social situation
of the Jewish minority, their sense of identity and the
degree of tolerance of the Gentile majority. Hence,
throughout the centuries, the synagogues were the
architectural seismographs for the prevailing
social conditions.

Salomon Korn
German Synagogues
An Introduction

As architectural buildings, synagogues are difficult to classify. While its threefold purpose as house of congregation (Beth ha-Knesset), house of education (Beth ha-Midrash) and house of worship (Beth ha-Teffilah) hints at the synagogue's manifold nature, it says nothing at all about its structural character. And indeed, it leans more to the side of spirituality than to architectural expression. The intangible content and its tangible form have never reposed into an "ideal" architectural form, but remain in a relationship of interactive tension. Even if the very nature of the synagogue prevents an ideal material expression, it does seem possible to approach the architectural ideal nevertheless. An understanding of this complex process requires a look at the most decisive steps in the development of the Jewish house of prayer throughout its long history.

"An awe-inspiring place! This is nothing if not a house of God, and here are the Portals of Heaven." These are Jacob's words upon awakening from the dream in which, on a ladder reaching from earth to heaven, the Angels of God ascend and descend – as if connecting heaven and earth.

Jacob lifts up the stone upon which he had rested his head, pours oil over it and calls it Beth-El: the house of God. Hence the idea of building a monument to God originates not by edict from God, but rather by the will of mankind. This distinction within Judaism has great impact upon the further development of the synagogue. Each congregant engaged in prayer is considered a lay-priest with a direct connection to God, and therefore nobody needs a middleman. Thus the synagogue is not truly a house of God, but first and foremost a house of mankind in the presence of God. The bible actually mentions this distinction rather early: during their encampment at the foot of Mount Sinai, God, calling upon the children of Israel, says, "Make me a sanctuary, and I will dwell among them."

From this point on, rather than praying to graven images they were to honor an invisible, nameless and shapeless God at a temporary and portable sanctuary, the tabernacle. Adherence to this requirement ultimately meant that the children of Israel had to relinquish any attempt to magically arrest divine power by giving God a material shape or form. At the same time this meant accepting His invisible omnipresence and, finally, the "triumph" of the spiritual over the physical. The dance around the Golden Calf shows just how difficult it was for the Jews to accept a deity which could not be fathomed by the senses. Equally revealing of this difficulty was the second Jewish house of God, The Temple of King Solomon. In borrowing from Phoenician architecture for its exterior, and thereby approaching

the heathen traditions of the peoples around them, it allowed for the gradual departure from the abstract monotheist principle. But beyond the mere characteristics of form, it is the strict hierarchical order of the priesthood, the sacrificial offerings in the temple, and the various zones of Holies that are indeed difficult to reconcile with pure monotheism.

The Temple of Solomon was not the appropriate architectural answer to monotheism, but rather a form of transition and compromise between idolatry and the belief in an invisible God. Most likely it wasn't before the complete destruction of the temple by the Babylonians in the 6th century BCE that it became a place of worship more suitable for monotheism. In the "non-sensory" synagogue, every single worshipper has a direct relationship to God, the preacher's podium replaces the altar, the non-bloody prayer replaces the bloody sacrificial offering, and the Torah with the biblical Scrolls of the Law replaces the Ark of the Covenant and its Tablets of the Law.

In contrast to the temple, where a succession of differentiated rooms corresponded to zones of increasing holiness (sacrificial offerings as ultimate activities of worship), the spatial demands on

early synagogues sprang from a rather different attitude. The worshippers no longer approached God in a ceremonial way, as if His presence was bound to a certain holy place at the center of the temple. Instead, His presence was now considered to be purely spiritual, i.e., He is everywhere and nowhere. The believers congregated around a certain area to hear God's words from those who were well versed in the scriptures. To accommodate such a congregation, it was necessary that the structure created a focal point, preferably elevated, so that the speaker could easily be seen and heard. The elevated podium, the bimah (the preacher's place) became the given physical and spiritual center of the temple. With the preaching word as the basis of the religious service, the structure had no further spatial requirements.

Aside from these rather secular teachings, the synagogue also had to accommodate regular sacred activities, above and beyond prayer. The spatial requirements of the synagogue needed therefore to satisfy not only the intellectual lecture, but also the spiritual moments of worship. One such sacred moment incorporates the Aron ha-Kodesh (also known as the Aron) the holy shrine holding the Torah (the biblical Scrolls of the Law) which on certain days at certain times during the service are taken out of the holy drawer, ceremonially carried to the bimah where they are read, and then carried back.

With regards to the intellectual history, the temporary synagogue of the Babylonian exile is more a return to the portable tabernacle of the desert rather than to the stationary temple of Zion. However,

since the tabernacle already embraces an important sacred part of the temple in the Ark of the Covenant (the Holy of Holies), the synagogue (with the holy Ark of the Covenant) combines elements of the tabernacle (secular, non-sensory, temporary) with elements of the temple (sacred, sensory, permanent), albeit to varying degrees of importance. Basically this means that the synagogue, in its rather turbulent history, vacillates between temporary and permanent, between living spirituality and ritualized ceremony, between the abstract and the tangible, between secular rationality and sacred mysticism, depending on internal and external conditions. These oppositional pairs find their physical manifestation in the conflict between the bimah and the Ark of the Covenant, or rather in their relative spatial position, their relative size and their formal characteristics.

Seen from an architectural point of view, the antique synagogue after Babylon in the Holy Land faced a problem with the ground plan rather than with the actual spatial design for prayer. The problem related first and foremost to the ever-shifting positions of the bimah and the Aron ha-Kodesh within the synagogue, until finally, not least for optical and acoustic reasons, the bimah found its

final "logical" position in the center of the room, with the Ark of the Covenant permanently moved into a niche in the wall which pointed towards Jerusalem, towards the temple. Due to its central position, the bimah demanded a building with a center, while the eastward movement of the Aron ha-Kodesh could be expressed through an elongated building. The spiritual conflict between the bimah and the Aron ha-Kodesh found its architectural and spatial expression in the conflict between centrality and longitude. Beyond that there are no architectural or even stylistic characteristics that would define the original synagogue. Brought to the point, the (exterior) architecture of the synagogue is interchangeable – the (interior) bipolar principle of space, the "space distribution of the synagogue" is not! As long as this principle is held up, the Jewish house of God preserves its specific and original character despite all the interchangeable architectural forms and stylistic exteriors it may embody.

Neither a singular architecture nor a particular style of construction specific to synagogues ever developed in the Holy Land. Lacking a fixed architectural style for their synagogues, the Jews of the Diaspora simply adopted the current architectural style of their host countries. As a result, for thousands of years synagogues were not recognized as the monuments of a socially marginalized minority. This is particularly true in Germany, where Jewish houses of God could only be built on the outskirts of a town or in courtyards, if at all. At the beginning of the 19th century the first attempts of Jewish

emancipation and an increasing sense of German nationalism changed all that. In this turbulent period every architectural style held meaning, a significance derived from the history of the West as well as from the Middle East, and any choice favoring a particular style was viewed as confessional in nature.

With regard to the construction of synagogues at the time it is significant that the desire for national unity, along with the nostalgia for the greatness of the German Christian Middle Ages, were expressed by way of the most sacred of all historical styles, the Gothic and neo-Gothic. Since, at the time, the answer to "the Jewish question" was conversion to Christianity, if Jewish characteristics were the focus of any synagogue construction, it was important to avoid stylistic elements suggesting an architectural and symbolic transition to Christianity. Yet at the same time, Jews wanted to declare in public their solidarity with their new Jerusalem, the German fatherland. Therefore architects, mostly Christian, were faced with the problem of differentiating between "German" and "Christian" when choosing architecture and style. It was necessary that the architect concentrates on the Judaic character of the

sacred building and thereby avoid resemblance to Christian churches, while at the same time emphasizing the German national character. This meant straddling a rather narrow fence considering that it was nearly always necessary to use Middle Eastern styles to emphasize a specifically Jewish character. Yet the use of neo-Islamic stylistic elements harbored the danger of arousing "un-German" associations; associations which would visually acknowledge and increase the social marginality of the Jews.

Gottfried Semper, when building the synagogue in Dresden in 1840, escaped this conundrum by using Middle Eastern elements on the inside, and Roman elements on the outside, while at the same time still hinting at elements of the tabernacle and the temple. As was the case with many later synagogues, the use of neo-Islamic elements was meant to evoke the memory and connection to the Middle Eastern roots of the Jewish religion, while the Roman (and later, Gothic) elements were intended to emphasize the connection to the German nation.

This eclectic style makes it apparent that the Jews, whose social status was still endangered, made every effort to find their own stylistic identity while at the same time professing their firm connection to Germany. The seams between Western exterior and Middle Eastern elements of style, which never found a true architectural unity, show the cracks that symbolize the social status of the Jews as they fought for legal, social and religious equality.

The fact that the use of Islamic stylistic elements was controversial within the Jewish community itself influenced the royal-Hanoveranian architect Edwin Oppler (1831-1880), Jewish by birth, to demand the renunciation of such neo-Islamic synagogues. In his opinion they had no relation to the modern

Jewish tradition, and ought to be viewed as aberrations. Following the architectural tradition of the Middle Ages, which meant adapting the synagogues to the current style of the host country, Oppler found his architectural ideal in the Christian church. He wanted to build in "purely German styles," as can be seen in the synagogues in Bleicherode, Breslau, Hamels, Hanover and Schweidnitz. If in centuries past this meant the direct adaptation of current architectural forms, by now it had become closer to a reproduction of a reproduction of historical styles of construction – a copy of a copy all the way towards visual self-denial, so that the Jew may "disappear within the German state." This, in turn, conjured up accusations that the Jews lacked originality and a sense of history, right at a time when the Jews were striving for social acceptance. There was no way out of this dilemma – the Jews faced social stigmatization either way. If Jewish congregations confidently built their synagogues in Middle Eastern styles, they faced the danger of marginalizing themselves visually, and if they built their houses of God according to "German" styles, thereby openly professing their connection to the German people, they were reprimanded for self-denial.

All of this must be seen in the context of the desire to be part of the German nation. The Jews in Germany tried to overcome their social stigmatization by calling themselves Israelites. Synagogues became temples. Along with the new name came a programmatical change: the promised land was no longer far away Palestine, but Germany. The place where the temple should be built as predicted

by the Messiah was no longer Zion, but Germany. Consequently many German cities saw the erection of large new temples, a visible profession of the German Jews – the German Israelites – as belonging to and accepting Germany as their promised land. Liberal ideas within Judaism gained the upper hand, and the architectural influence of the Christian church became more and more evident, resolving, in part, the age-old spatial conflict within these synagogues. The "orthodox" central placement of the bimah, for example, was no longer considered timely to the liberals and reformers within Judaism. Following the Christian ceremony, the bimah was now moved from its central location to a placement closer to the eastern wall of the synagogue, near the Ark of the Covenant. Relieved thus of the original spatial arrangement typical of earlier synagogues, the house of God, often defamed as a "school for the Jews," became a "synagogue-church," a new temple for the new German Israelites.

A sorrowful two-thousand year journey of the Diaspora seemed to have come to a happy ending. This illusion was not to last very long. This most fruitful period of German-Jewish history came to an end on the night of November 9, 1938, with the burning of the synagogues all across Germany. 150 years of painstaking efforts to gain civil and legal equality went up in smoke on this night of horrors.

The Nazis believed that, aside from the material destruction of all Jewish houses of God, the burning of the synagogues symbolized the destruction of Judaism at its innermost core. The unrequited love and the deep sense of belonging the German Jews felt for their German fatherland burnt to ashes as well, along with their synagogue temples, on this Night of Broken Glass – the Reichskristallnacht.

Not only are there virtually no more synagogues to be found in German towns since, but synagogues have virtually disappeared from the consciousness of the German people. At the dawn of the 20th century there were approximately 2,800 synagogues and Judaic places of worship in Germany. Over half were destroyed, most of them on the very night of November 9,1938, others in the wake of the war. Of the structures having survived both the Reichskristallnacht and the war, most were otherwise appropriated, sold or torn down. The memory of a blossoming architectural genre in Germany has virtually been wiped clean.

Since 1995 several monumental German synagogues have been reconstructed in virtual reality. Others will follow. Will the visualization of what has been destroyed, the spatial reconstruction of former synagogues within a computer, manage to create a consciousness of the dimension of what has been lost? Many of those who enter the virtual synagogues are surprised by the foregone splendor of these houses of God. But many questions remain unanswered. The loss of a human being, of a living creature, of any thing, can only be fully appreciated if you have been close to them, if they have been part of your own life, your own history. Is it possible to feel something similar when walking through a synagogue reconstructed in virtual reality? Or will the beholder remain emotionally detached, feeling merely regret rather than loss? For no matter how detailed, the virtual depictions are empty, devoid of the human beings who gave the actual houses of God their life. Their artificiality cannot be overcome. Yet it is exactly this distance that is necessary to prevent us from falling prey to the illusion that it is possible to reproduce the synagogues in virtual reality, and thus make them indestructible for the future – as if we had won a belated victory over the Nazis. The synagogues will not return to the cities and towns in Germany, and therefore not to the consciousness of the German population. Just as previously blossoming Jewish congregations have been reduced to books of remembrance, so the destroyed synagogues have been reduced to moving pictures. They are far removed from reality. Yet they have been saved in an unpredictable fashion for historical purposes, for architectural purposes, and for museums. This may not mean a great deal for the collective memory of the German people, yet for science, for those who are interested, for those, who gave life to the virtual synagogues, it does. What a grandfather destroys forever, a grandchild can never create anew – not even in virtual reality. Yet in amazement and gratitude we acknowledge the fascinating images they have brought back from the darkness of history so that we may remember – forever.

Marc Grellert

The Potential of New Media for Acts of Remembrance

Remembering Destroyed Synagogues

Over the last several years the significance attained by the new media is such that many areas of social life cannot be imagined without them. The continuous development of information and communication technologies, and the development of the Internet in particular, has changed our habits and offers opportunities that were unimaginable just a few years back. This development does not stop short of our acts of remembrance.

3D CAD simulation, a technology which has been in wide use only in the last ten years, has made possible the electronic representation of pre-existing architectural accomplishments long since destroyed.

This form of reconstruction is not possible via traditional methods, such as drawings or architectural models. 3D CAD simulation makes it possible to enter a three-dimensional computer model and visualize it through every conceivable point of view within moments, gaining spatial impressions on a natural scale from the perspective of the beholder. Our visual imagination of space is intensified by 3D CAD simulation. Virtual tours in and outside of the buildings add to this effect.

The allure of this new technology, as well as the interest in architecture and the Nazi years led me to the idea, triggered by the arson of the synagogue in Lübeck in 1994, of reconstructing, within the computer, the synagogues which had been destroyed during the Nazi years. The spatial impressions we achieved – memories of what has been destroyed – are now available worldwide through the Internet. Wrapping acts of remembrance in the inherent potentials of the communication and information technologies opens a bright future for such acts in general, and for those of prior architecture in particular. The rise of the Internet, available to the general user for only a few years, has opened the cultivation of remembrance to the world regardless of space and time. In my opinion, the Internet is the most important medium of remembrance within the whole new media. It is a non-material world in the public realm. This non-material world offers opportunities for remembrance which go above and beyond the material world. While in the material world acts of remembrance take on a receptive character, due to the one-way transmission of messages and information, the non-material space of remembrance can embrace both action and interaction. "Visitors" can open a dialogue amongst each other or with those providing the information. In the future it may possible for visitors and historical witnesses to meet in non-materiel space – in a virtual synagogue. The encounter itself, along with communication that is both active and reactive creates an interactive form of remembrance. Within the non-material space of remembrance those interested may themselves become part of the process of digesting history. While the material location in the city shows only one aspect of the past (in this case, the reminiscence of a synagogue) the non-material space offers an all-inclusive approach. The Internet is able to create an endless stream of connections to other non-material places of remembrance, combining them in such a way that ever more complex impressions come into being. The potential of immediately updating contents and connections to other Internet addresses, is yet another advantage of digital remembrance. This accommodates a notion of remembrance as a process and a dialogue.

Examining the potential as well as the limitations and conditions of the cultivation of remembrance in new media with the example of the synagogues has been and remains part of the research in the Department of CAD in Architecture at the Darmstadt University of Technology, Germany. One result of this research has been the development of a non-material monument to the synagogues that were destroyed: an interactive archive in the Internet. Starting with the hypothesis that remembrance will be more potent if people are active partners rather than mere recipients of what traditional institutions of cultural memory, like the monument or the museum, have to offer, the Synagogue Internet Archive allows the user to actively participate in the creation of the archive. The basic structure offers information on 2,100 synagogues which still existed in 1933. This information is taken from literature

and includes the location of the synagogue, complete with street, city and federal state; the period during which it was used; the extent and date of its destruction during the Nazi years; the actual date of its demolition; information regarding the remains of the building and the furnishings; as well as information regarding existing forms of remembrance. The user can add witness reports, comments, links or pictures relevant to the synagogue of his or her choice in the archive, thus enriching the basic information. Background information completes the archive. For the very first time this archive creates an overview of German synagogues, including the Eastern states, which can be updated continuously. Statistics allow more precise numbers with regards even to partial aspects. For example, who would have known that 350 synagogues and houses of prayer had been demolished only after World War II? The Synagogue Internet Archive (www.synagogen.info), as well as the virtual reconstruction of the synagogues, are available at www.cad.architektur.tu-darmstadt.de.

The generations of the 21st century will use the World Wide Web to access information and ideas with natural ease. The cultivation of remembrance, if it wants to remain significant, must embrace this fact. Authentic locations of memory do not become superfluous, of course. Relevant remembrance can happen in parallel spaces: historical authenticity in the material space, and non-material remembrance in the digital net. The material location will need to make its characteristics relevant, by

emphasizing its sensual aspects, which can only be achieved in the material world. Remembering the synagogues at the authentic location should therefore, in my opinion, address the immense loss for the urban landscape. The synagogues were part of a shared culture of Jews and Gentiles in Germany, and left their mark on the cityscape of many cities. This is no longer comprehensible in today's cities. If there is anything at all to remind us of the synagogues, it is a commemorative plaque or stone telling us the story of the existence and destruction of the building. Wherever architecturally possible, remembrance should, in my opinion, go above and beyond a mere mention of historical fact by adding an architectural and spatial dimension. This would allow us to comprehend the significance these synagogues once had on the urban landscape. One example is in Vienna: the original space of the synagogue in the Tempelgasse is marked by four mighty columns that allow us a glimpse of the contours of the synagogue's entrance façade. Another example is the former synagogue Börneplatz in Frankfurt, where the contours of the foundation are visible in places

where the location is undeveloped. If the architectural situation won't allow for such solutions, we ought to consider other indirect ways by which the forced development of urban features in the wake of the synagogue's demolition could be commemorated.

If we agree that the memory of the Holocaust should be passed on to future generations in the hopes of learning the lesson for the present and the future, polls such as that conducted by the Institute of Mass Communication in Cologne in 1998 are rather worrisome. According to this poll, one-fifth of 14- to 17-year-olds who were questioned had never heard of Auschwitz. Two-thirds of the teens questioned could not even approximate the number of the victims murdered in the concentration camps. I believe this calls for new methods of remembrance that are attractive to the young. Here the new media play a significant role. Therefore I hope that the computer reconstruction of the destroyed synagogues, the non-material memory on the Internet in combination with reports from witnesses and background information on the Nazi years, Jewish culture and architecture, will offer a new incentive to deal with the crime of National Socialism, making us ever more alert to new anti-Semitism.

Manfred Koob
Visualizing What Has Been Destroyed

"Synagogues in Germany – A Virtual Reconstruction" is the title for an exhibition which wasn't planned as an exhibition at all, and whose form was agonized over throughout its various stages of preparation. For in its heart lay that which no longer exists, that which was destroyed. Because of this, the focus of the individual exhibits within the exhibition is not of substantive material but rather a complex process. This process is hard to describe as it is inextricably bound to those who have been working on the project, along with their individual experiences, their knowledge and their memory.

In the spring of 1994 eight students of architecture at the Darmstadt University of Technology in Germany, asked me to conduct a seminar entitled "Visualizing What has been Destroyed." This was at a time in which the marginalization of minorities was becoming more noticeable, as was an ever growing right wing extremism. It was the year which saw the arson of the synagogue in Lübeck. With the virtual reconstruction of the synagogues destroyed in the Reichspogromnacht (known as Reichskristallnacht or "Night of Broken Glass"), the students wish to remember and admonish, while

setting a signal of their own way of thinking and acting. At the same time they want to remind us of the synagogues' architectural significance, considering that synagogues once defined the urban landscape of many German cities. They were able to reconstruct three synagogues in Frankfurt: the synagogue at the Börneplatz; the synagogue at the Friedberger Anlage; and the main synagogue in the former Judengasse.

In the beginning of the project I had to face my own insecurities and reservations, which were soon dispelled by the students' lack of concern and their determination to make what has been destroyed visually available. My early reservations as to whether such a project would even be appropriate to begin with were quickly dispelled by conversations with survivors of the Holocaust and their descendants. Most encounters were ruled by an atmosphere of mutual congeniality, openness, communication, curiosity and keen anticipation of what was to come. We shared such experiences together, students and teachers alike, and grew to accept as fact what is, ultimately, unfathomable.

Architecture is a petrifaction of the social order. Architecture tells us about the thought processes and actions of those who lived before us. The same is true for architecture destroyed by human hand. The systematic destruction of synagogues and houses of prayer, more than 1,400 of them, was

fraught with the foreboding of what was to follow. The murder of approximately six million European Jews in the wake of the destruction of the visible part of the growing Jewish culture in Germany. We realized that with the destruction of the buildings, construction files and documents were also destroyed, some destroyed methodically by followers of the Nazi Regime, and some in the wake of the war. Only a few fragments remained, only a few traces are left today to help us recreate an image of the destroyed synagogues. We also realized that up until recently these fragments, as well as the original locations of the synagogues, had been treated with ignorance and insensitivity.

We became aware that fewer and fewer people could report about the time when the synagogues were burning. Meeting survivors for the first time, starting a dialogue with them, hearing what had happened, where they used to pray, what they still remember, was an individual encounter for every single one of us, an awkward and precarious encounter.

In the summer of 1996 we created the first digital images based on a few documents as well as on information attained from witnesses that were still alive. These are images arising out of a dialogue

with the past, with the Jewish culture and the Jewish faith, as well as out of meetings with survivors. These are images of German cities, German streets, images of a German past which show the Jewish culture blossoming in this country. And yet they are images which unwittingly resemble digital graves, images without life. They point to an irreversible destruction, to the fact that they are only an illusion of an eternal present. And together, historical witnesses, teachers and students alike, we have to realize that across the generations we are part of a common process of remembrance.

Under the supervision of Marc Grellert and myself, and guided by the positive response to the Frankfurt project and by the political interest it created, the Department CAD (Computer Aided Design) in Architecture aims to recreate fourteen additional large synagogues by computer. In addition to the political ramifications, the project aims at creating a representative overview of

the wealth of the synagogue architecture in Germany prior to its destruction. We chose 14 Houses of God from the cities of Berlin, Cologne, Darmstadt, Dortmund, Dresden, Düsseldorf, Hamburg, Hanover, Kaiserslautern, Leipzig, Munich, Nuremberg, Plauen and Stuttgart.

Since the Darmstadt University of Technology only has limited funds available for such an extensive project, funding had to be found elsewhere. In 1998, with the support of the Federal Ministry for Education and Research, we launched the project with a reconstruction of the synagogues in Cologne, Hanover and Plauen. The federal support and funding made a continuation of the project possible, while also encouraging further sponsorships. The cities of Kaiserslautern, Munich and Nuremberg then joined the project and sponsored the reconstruction of their local synagogues. More than 40 students are part of the process of reconstruction by now. Public awareness of the project grew. Under the scrutiny of the public eye, the project took on a more awkward, less innocent tone. On the one hand, the project needed to meet the scholarly standards; while on the other, the project ought not to lose the courage to present only fragments of information and data, if no more is available. Numerous letters and e-mails from German Jews strengthened our resolve to bring images from the past back to life. It's almost as if these images are but a symbol of the activity itself. The exhibition, which wasn't even supposed to be an exhibition at all, is but a report on a work in progress: the creation of a new generation's memory, the memory of grandchildren.

The exhibition was first presented at the Art and Exhibition Hall of the Federal Republic of Germany in Bonn. Many museums and institutions in the cities of the respective synagogues wanted to carry it as well, yet the financial constraints were prohibitive, considering that the exhibition has to be completely reconstructed every time. Dr. Walter Homolka and the generous contributions of the Deutsche Bank have finally made the exhibition accessible elsewhere, particularly outside of Germany. In the meantime, the work on the synagogues which was still in progress while the original exhibition in Bonn has been completed. The interior of the synagogues in Nuremberg, Kaiserslautern and Dortmund has been finished. Work on the synagogues in Leipzig and Dresden will resume just as soon as financing has been secured. The cities of Mannheim, Bad Kissingen and Hamburg have followed the example of other cities before them. Their synagogues were reconstructed by request, with the help of local institutions and individuals.

Reconstruction means "recreating or imitating the original condition." Do not be mistaken, this is not what we had in mind with this project. Since the early 1980s technological developments have

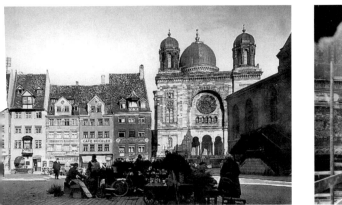

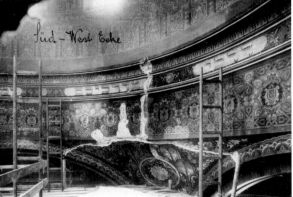

made it possible to create three-dimensional geometries on the computer, and to create the illusion of two or even three dimensions, as if we were dealing with the real thing. It was obvious that this technology would be used in the service of architecture before long. Design and plan are the simulation of an architectural concept which the architect creates through two- or three-dimensional techniques such as drawings and haptic models. The transformation of his ideas helps the architect, as well as others, to represent the concept of the building and to check it against this representation. The reconstruction of historical buildings and urban landscapes use the same method. In both cases informational technologies, in particular CAD, offers the opportunity to look at the buildings in three dimensions and of simulating their conditions on the computer. The technology begs to be employed in the treatment of historical sites, since it allows us to visualize those elements of our architectural past that have not been rebuilt. Since its conception, the Department of CAD in Architec-

ture at the Darmstadt University of Technology has reconstructed more than 90 buildings which have either been destroyed or never realized to begin with, creating their visualization for the layperson and specialist alike, from the cloister grounds Cluny III in Burgundy to the Vatican Palaces of the Renaissance.

The reconstruction of buildings from the past is based on the combination and compression of knowledge from various sources. It is a fusion of blueprints, contemporary photographs and representations as well as written documents. From these numerous sources we construct a whole, accounting as well for sometimes contradictory elements. When there are too many contradictions, or too many holes, those responsible for the reconstruction have two choices: either we accept this deficiency; or we use additional reconstruction methods, attempting to incorporate first and foremost the zeitgeist which influenced the architecture, the thought processes of the architect, the contemporary buildings and architectural rules that made their mark on the building. Certainly this procedure may be questionable; some may even consider it unscientific, because it might lead to a false account of

the past. In the case of the reconstruction of the synagogues that were destroyed in the Reichspogromnacht, the incorporation of such methods is unavoidable. Without such projection it would be impossible to create an image of the lost architecture of these German monumental synagogues.

The 35 participants of this two-term course in CAD were required to attend the art history seminar conducted by Professor Wolfgang Liebenwein at the Darmstadt University of Technology before transferring their work to the computer. As they were dealing with the history of the synagogue architecture, the participants of the seminar had to research their chosen synagogues for representation

Illustrations page 32 / 33 show the
synagogue in Nuremberg (Hans-Sachs-Platz)

left page left: Photograph of the front side of the synagogue
right: Detailed photograph of the dome

top: Drawing of the dome
bottom: Ground plan

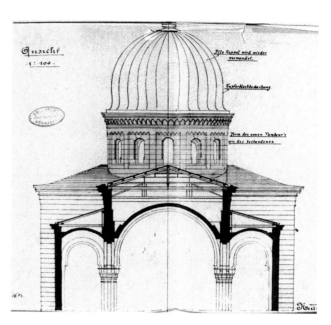

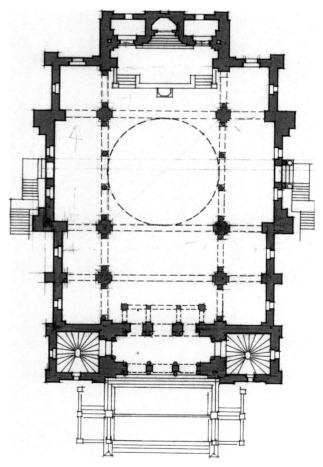

through literature as well as by way of their actual
location. This included an encounter with
witnesses. All of us, particularly the students, were
surprised that archives, Jewish communities and
witnesses welcomed them with open arms and
strongly supported their endeavor.

The research that began in the art history seminar
continued in the second semester. In cooperation
with the local city offices and Jewish communities,
plans, pictures and texts documenting the de-
stroyed synagogues were examined and evaluated.
After this evaluation and analysis of the textual
foundation, we took our first steps on the computer.
We created a horizontal and vertical line scaffold-
ing on the computer to mirror the structure of the
building. This scaffolding formed the basis of scale
as well as a method of spatial orientation, which
would later allow us to locate architectural ele-
ments and interior decorations. At the same time, the
scaffolding provided the necessary filing structure
of the virtual synagogue's individual elements.

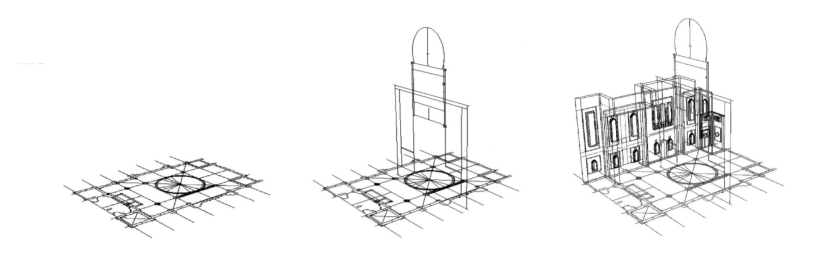

Following the method and logic of constructional engineering, the next step was to analyze the elements and to represent them in only two dimensions. While this step was vital in the beginning, it lost significance as the construction progressed, as the growing technical abilities gradually made it possible to create certain elements in three dimensions immediately. The creation of the so-called line scaffolding and the two-dimensional treatment were essentially a virtual imitation of any planning and foundation necessary for the actual construction of a building in the real world.

Parallel to the development of two-dimensional elements, a three-dimensional model was created. The CAD model is a 3D volume model. Compared with a flat model, this 3D volume model has the advantage of easily identifying and locating the individual elements. An additional advantage is that the elements which reoccur throughout the building, which is rather typical of synagogues, can simply be duplicated. If during reconstruction we find that the element needs to be modified, it can be replaced simply by renaming it. Since the reconstruction of synagogues is based in part on very rudimentary information, steps such as these are necessary as new information becomes available, from witnesses, for example, requiring the modification of any given element.

Once these individual elements have been developed, they must be put together to form building blocks with which a logical whole can be formed. A column of the main aisle, for example, consists

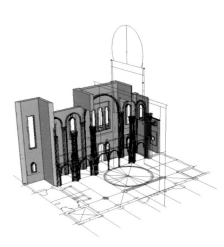

top from left to right:
Ground plan in virtual 3D space
Ground plan and cross section in 3D space
Construction of the virtual model – north wall as wire frame model
Shaded model of the north wall
Assembly of the individual building elements

bottom: Completion of modeling

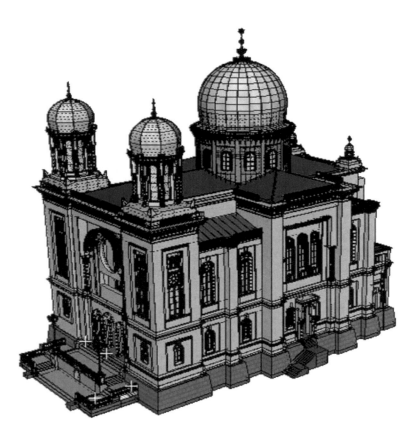

of a base, a shaft and a capital. The column will be filed as a whole, and can be duplicated several times if necessary, and thus it does not have to be created more than once (as opposed to the ten times it would have to be built in reality).

Following the logic of the creation of a virtual synagogue, the different building blocks are now put together into building groups. These, too, are filed and reused if they occur more than once. And, as in all previous steps, these groups are placed within the central line scaffolding.

In the last step of the geometrical treatment, the groups are combined into building segments and placed within the whole model. Now technology allows us to look at the geometrical space, the building, from all perspectives, inside and out. The consistent three-dimensional treatment of every single element makes the entire structure of the building, its architectural soul as it were, visible.

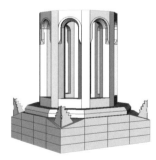
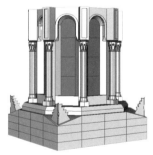

left page top: View of the top of the towers of the synagogue in Nuremberg
bottom: Steps taken in the modeling of a top of the tower

right: Completed model of the top of the tower

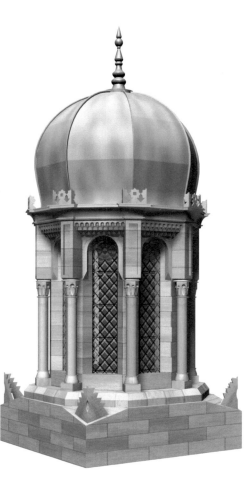

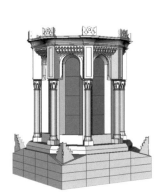

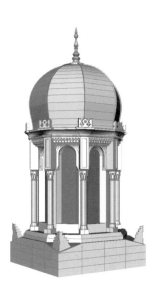

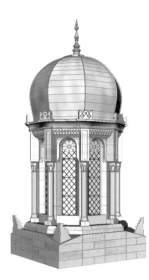

top left: Documentary photograph
for producing textures
top right: Section of photograph for producing
the texture of the arcades
middle and bottom: Drawn pattern of the arcade
based on the photograph

right page top left: Arcade without textures
top middle: Arcade with projected textures
top right: Completely textured arcade
bottom: View of the arcade

Each step in the creation of the model, from the
building segments to the individual elements,
the individual body is identifiable both as body as
well as through its individual surfaces. This makes
it possible to assign a certain material for the body.
The assignment of materials deals with two
aspects. On the one hand, the assignment is invisible
information, information on this particular el-
ement being connected with sandstone, for example;
while on the other hand, the assignment is pre-
sented as a red surface with a stone pattern. The
representation of these surfaces can be achieved
either through texturizing the material or through
generating the material. Allow me to describe
both possibilities quickly. Wherever the surface
showed an unmistakable uniqueness, such as
wall paintings, texturizing was used.

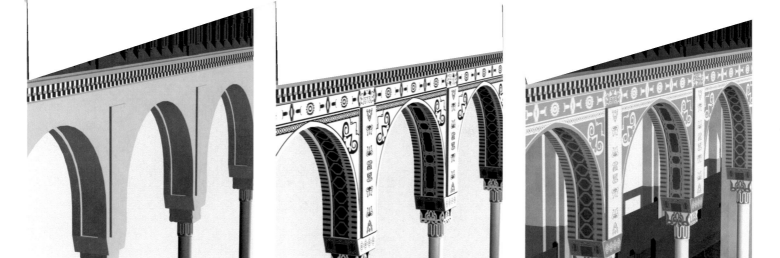

Generated material was employed with recurring material, such as stone. To texturize in such cases you'd have to take a photograph of all stones that no longer exist, because using the same drawing or photograph of stones wherever they recur, creates an unnatural stereotypical repetition. Generating materials, on the other hand, avoids this effect because the used programs create surfaces that, while similar amongst each other, used individual stones.

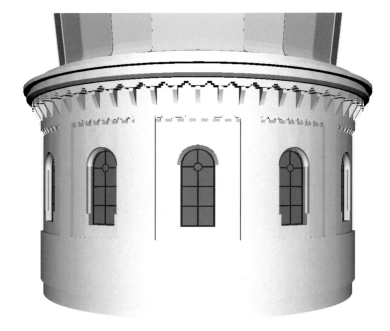

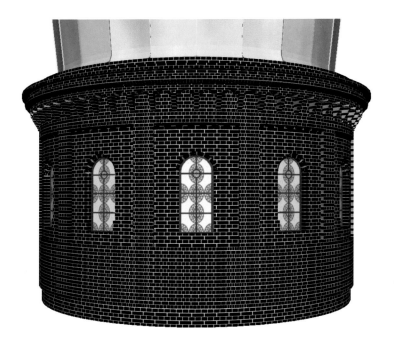

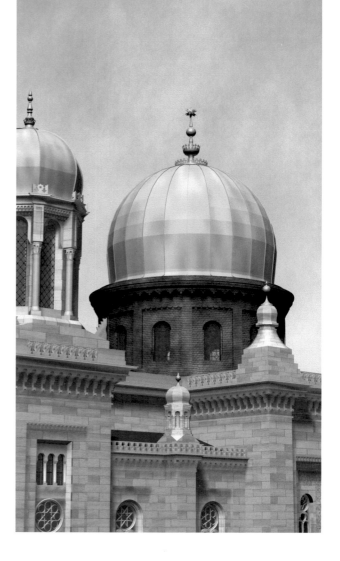

bottom from left to right:
Tambour without assignment of materials
Structure of the brick stone façade projected onto the tambour
Tambour with the final brick stone surface

top: View of the tambour and the dome

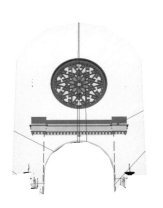

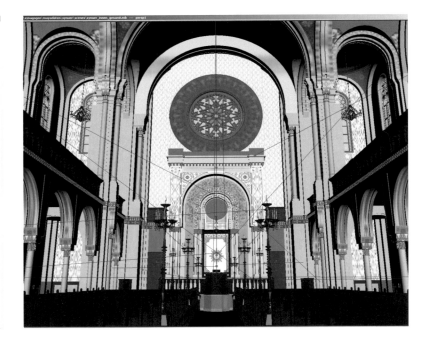

The key to visualization is lighting. The computer makes it possible to create an ambience by using light together with the geometry and surface characteristics. The procedure is rather complex and requires a great deal of experience since, on the one hand, most programs do not incorporate the basics of the interaction of material and light and, on the other hand, the technical parameters of the original indoor lighting and the natural outdoor lighting are unknown. If you were to aim at an absolutely identical reproduction of past reality, you would have to access the technical parameters of the lighting of the destroyed synagogues. Since this is not possible, the effects of light on these images recreate an approximate ambience, not a simulation of reality.

After modeling the geometry, assigning materials and creating a lighting scenario, the still photographs need to be calculated. The virtual camera has complete freedom within the virtual space and the object created within. The virtual photographer has complete access to the synagogue, any and all places inside and outside, and can virtually photograph it from all possible points of view. The virtual photograph corresponds to the common two-dimensional photograph we know today.

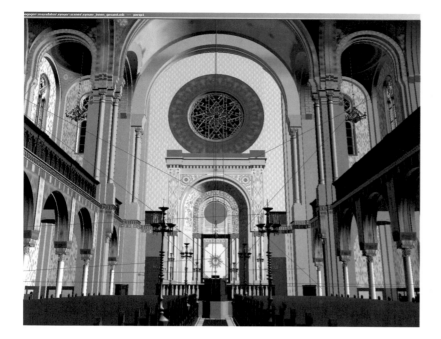

top from left to right:
Model without assignment of materials or lighting
Model with assignment of materials but without lighting
Model with both assignment of materials and lighting

bottom: Final image of the interior

left and right page:
Procedure to create camera movements

Illustration pp. 46/47: View from the west gallery

A film within the computer is created much in the
way an actual film is made. A succession of 25
still photographs are played within one second to
create the illusion of movement. A one minute
film requires 1,500 perspectives. The project plans
45 minutes of film, corresponding to 67,500
perspectives. The assembly of the individual scenes
could be imagined as follows: First we determine
the beginning and ending view point of the camera.
Between these two view points, the virtual camera
would move on a predetermined line. The pivoting
of the camera, as well as changes in speed and
focus would all be possible during such a camera
track. The virtual camera in the virtual model can
shoot such camera movements which, if they were
shot in reality, would require a huge technical
expense, if they were possible at all.

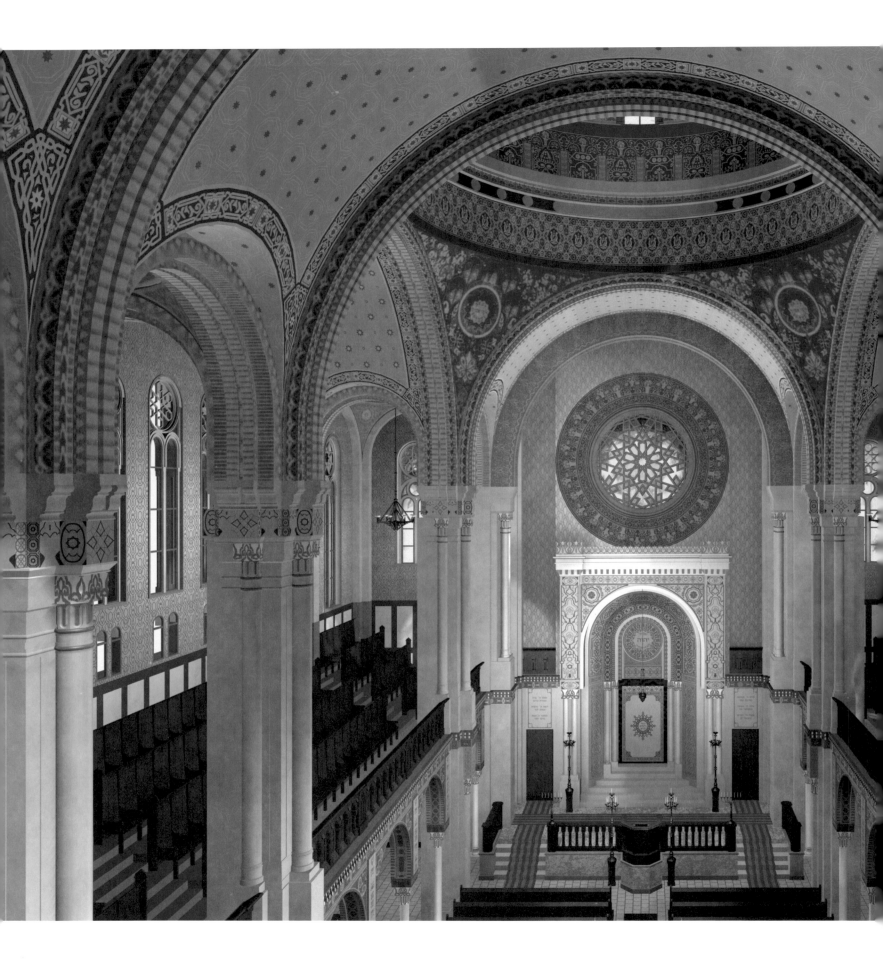

The question that came up again and again in these eight years was, what should become of the recreations once they were finished? The reaction to their presentation on the Internet, and the measurable number of visitors, shows that the Internet has become a popular place of documentation. More and more people, particularly young people, acquire their knowledge from the World Wide Web. The presentation of history has to take advantage of this medium eventually. The parallel reality in the Internet is a timeless construct, developing at breathtaking speeds towards an unknown future, leaving us forever curious about the present. The presentation of the past and its admonishing commemoration is new territory. Successfully supplementing other more tried and true methods, this project might set a new standard for a dialogue with, and the presentation of, history.

RECONSTRUCTIONS

Nuremberg

Nuremberg

Hans-Sachs-Platz, 1874 – August 10, 1938

The synagogue in Nuremberg, designed by the architect Adolf Wolff in Moorish style, was erected between 1869 and 1874. Seating 935 persons, the house of worship was a rectangular building with a transverse section, or transept, in the eastern third of the building and a tall tambour cupola over the crossing. The synagogue's interior was divided into three sections: the vestibule, the prayer area, and the estrade, a slightly raised platform with the bimah and the ark. The prayer area was subdivided into three aisles by round-arched Moorish arcades and decorated with oriental ornamentation.

When the synagogue construction began, the Jewish community, founded in 1862, had some 2,000 members, most of whom had a liberal religious orientation. By 1932 the Jewish population had grown to 9,500 persons; this, however, constituted only a relatively small percentage (2.5 percent) of the general population. The development of this community came to an abrupt end with the National Socialists' rise to power.

Nuremberg, the city of the Reichsparteitage (the National Socialists' party conventions), was one of the cities in which the order to destroy the synagogues had already been given before November 9, 1938. Julius Streicher, head of a Nazi administrative district, gave the command to tear down the synagogue at a large rally on Hans-Sachs-Platz on August 10, 1938. By autumn 1941 there were only an estimated 1,800 Jews left in Nuremberg, for many had emigrated to other countries due to the anti-Semitic measures of the new rulers. Between 1942 and 1945 a total of 1,650 Jews were deported from Nuremberg; only 72 survived the concentration camps. Whereas just a handful of Jews lived in Nuremberg after 1945, today the congregation again has about 850 members; many of them have come during the last decade or so as immigrants from the former Soviet Union. Since 1971 a memorial erected by the city stands on the site of the former synagogue.

left page top: Top of the tower on the west façade
bottom: View from the southwest

top: View of the entire building

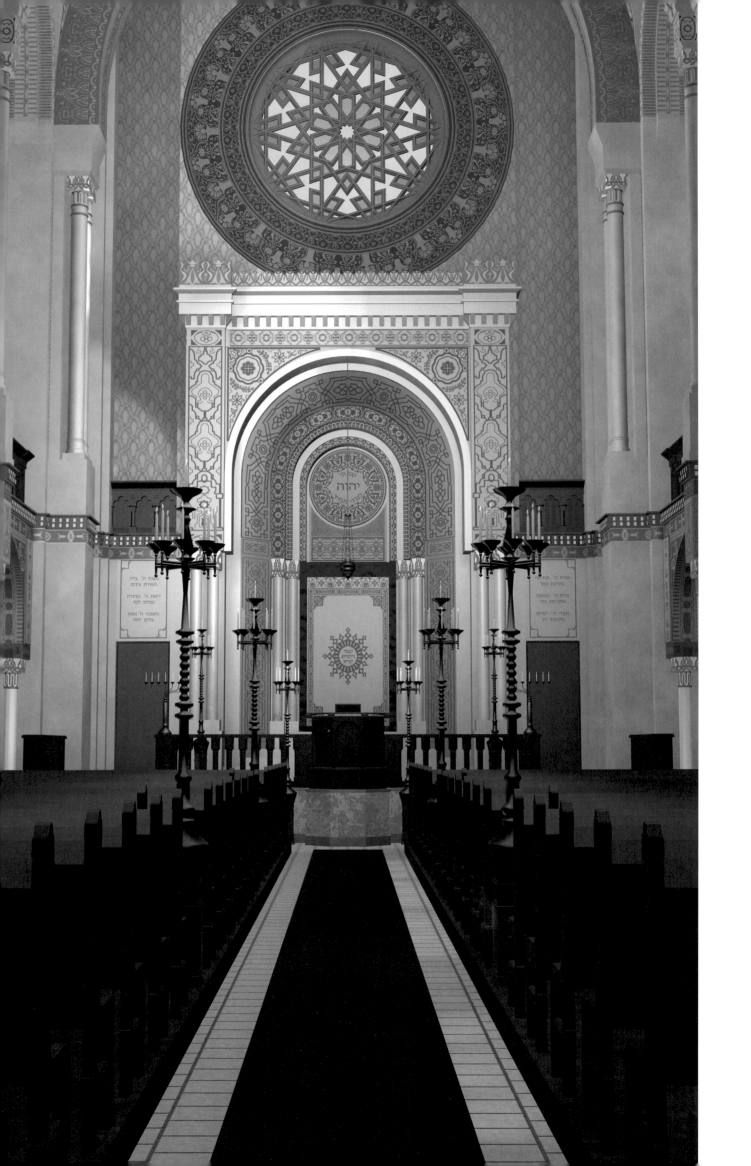

left page: View from the entrance of the Aron ha-Kodesh

left: View from the dome
right: View from the women's gallery

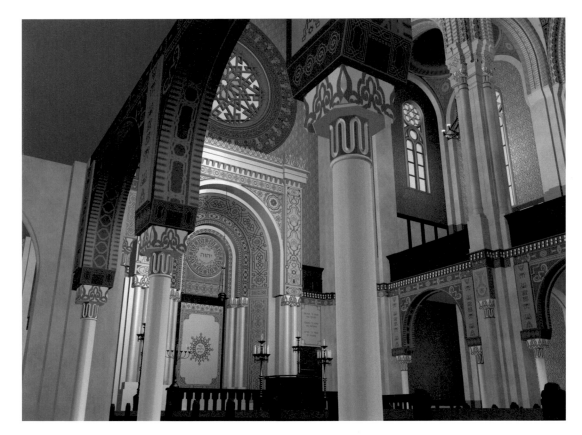

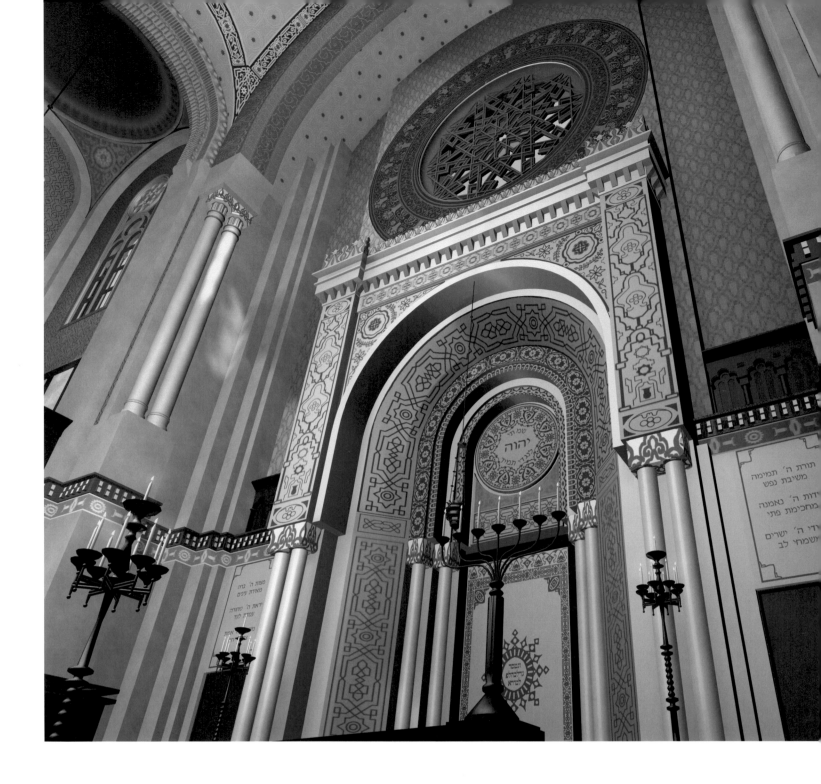

left page top: View from the aisle
bottom: View from the west gallery

top: Detailed view of the Aron ha-Kodesh

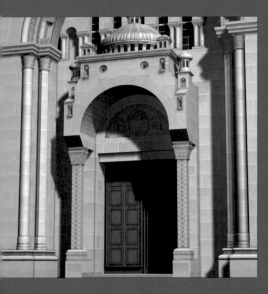

Berlin

Fasanenstrasse, 1912 – November 9, 1938

In 1907 a competition was held for the construction of a new synagogue on Fasanenstrasse in Charlottenburg. The jury selected the plan of architect Ehrenfried Hessel. His design was distinctly different from those of previously erected synagogues, which were characterized by a national interpretation of the architecture of the Middle Ages. The building was erected between 1910 and 1912 in Romanesque style; however, the design dispensed with the German Romanesque architectural details and used oriental ornamentation instead. The portals of the main façade featured ornamental archivolts (relief moldings that framed the arches) and ornamental stone canopies at the center. This new architectonic orientation was also connected with a new concentration on the core traditions of Judaism around the turn of the century. The main building accommodated 1,964 persons. The side wing housed a religious school as well as rooms for community use.

On Reichspogromnacht, the night of November 9-10, 1938, when pogroms took place across Germany (also known as Reichskristallnacht, or the "Night of Broken Glass"), the synagogue was severely damaged, and it was further destroyed during the war years that followed. In 1933, the twelve synagogues of the Einheitsgemeinde (united congregation) included about 175,000 members; in 1945 there were about 2,000. In recent years, the membership has again increased to about 12,000, due in part to immigration from the former Soviet Union. In 1959 a community building was erected on the site of the old synagogue; it now houses, among other things, a library, a Kosher restaurant and an Internet café. The domed portal of the historic synagogue has been integrated into the entrance area of this new building, and a permanent exhibit to commemorate the destroyed synagogue is on display in the foyer.

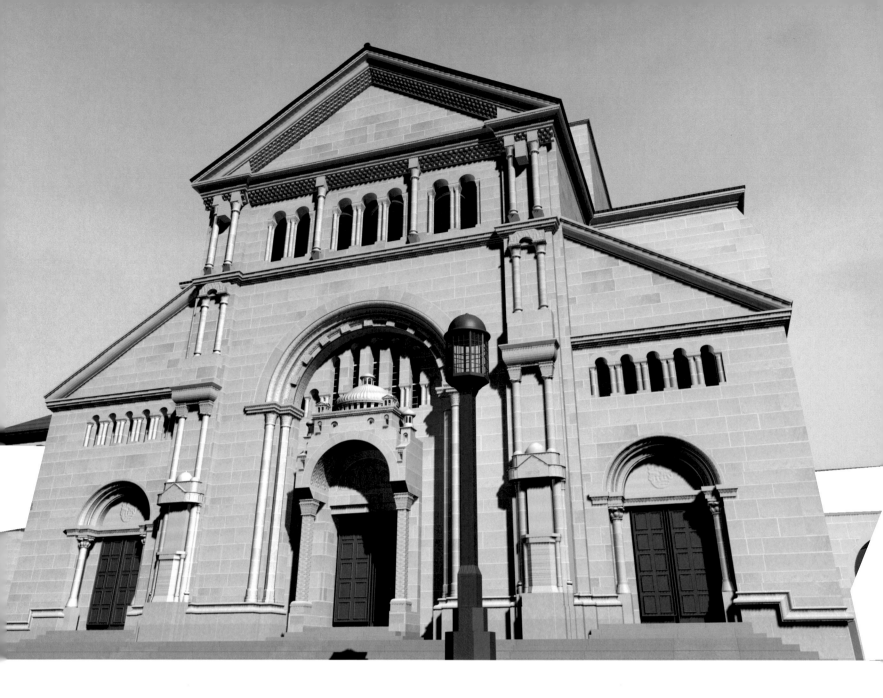

left page: View of the entire building

top: Front view

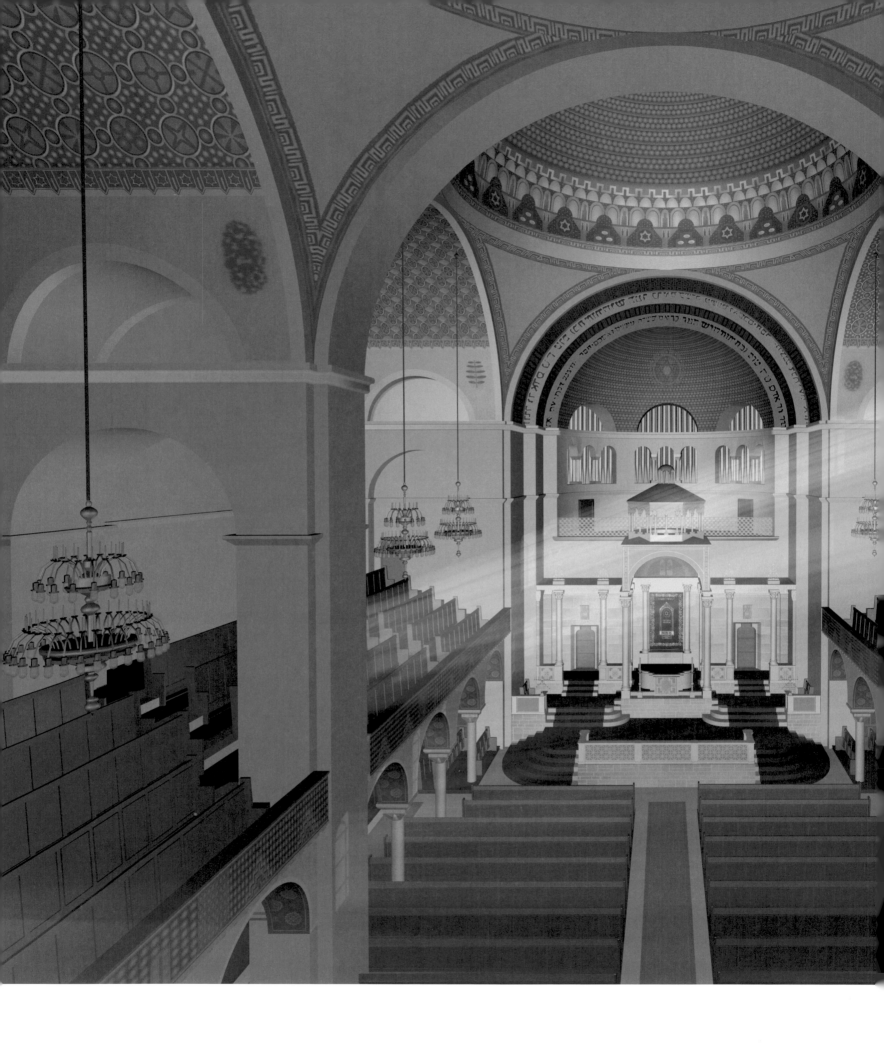

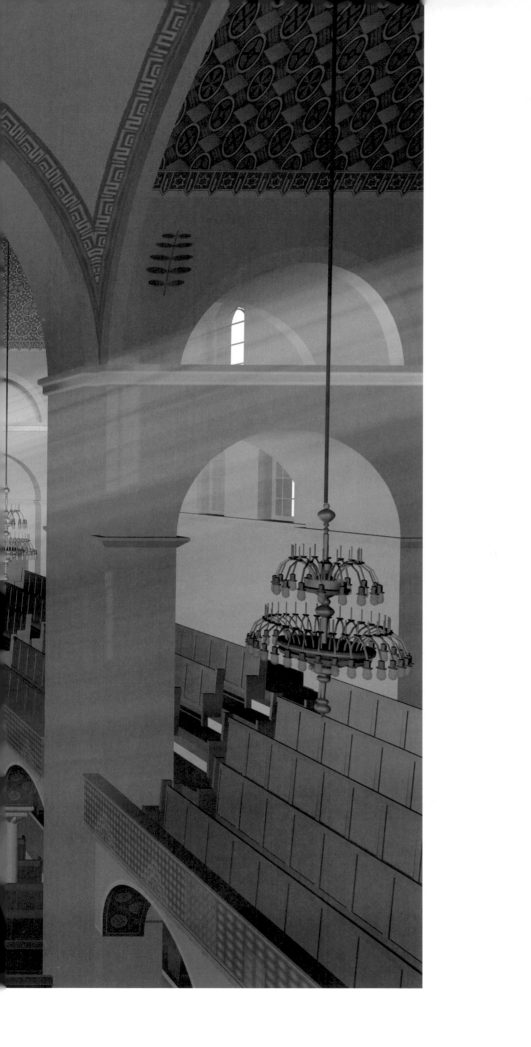

Illustration page 62/63: View from the west gallery

left: View from the aisle
right: View from the apse of the west gallery

top: View of the Aron ha-Kodesh
bottom left: On the west gallery
bottom middle: View of the west and north galleries
bottom right: Looking up into the dome

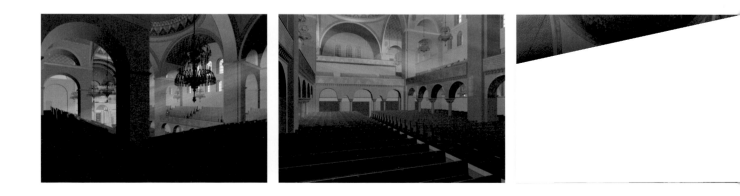

Cologne

Glockengasse, 1861 – November 10, 1938

By the middle of the 19th century, the Jewish community of Cologne had grown to about 1,300 members, making it necessary to build a new synagogue. The construction of the "Great Synagogue of Glockengasse" was made possible by a generous donation from the banker Abraham Oppenheim.

The architect was the privy building councillor Ernst Friedrich Zwirner. The cornerstone was laid on June 30, 1857, and the consecration ceremony took place on August 29, 1861. The synagogue was built in neo-Islamic style as a centralized construction surmounted, by a tall cupola. The cube-like exterior was dominated by the colored striped pattern of the façade, with its small towers resembling minarets and pinnacled cornices. The gilded cupola rose over the prayer hall, which had an impressive richly colored interior. The synagogue provided seating for 226 men and 140 women. In accordance with the congregation's conservative orientation, the bimah was situated at the center of the hall. Around three sides of the room there were two stories of galleries made completely of cast iron. At the eastern end of the room was the white Carrara marble Aron ha-Kodesh, or Holy Ark.

Soon after its construction, the synagogue proved to be too small for the growing congregation and an additional structure was planned. However, since the front wing of the building was to give way to urban renewal—Glockengasse was to be widened— the congregation was already thinking about selling the property. A decision was never made, as the synagogue was completely destroyed during the Reichspogromnacht of November 10, 1938. In 1943 the property was transferred to the city of Cologne, which between 1954 and 1957 erected a new opera house on the site. Today a memorial plaque is the only reminder of the Jewish house of worship that was once one of the city's artistic landmarks.

Constantin Ehrenstein Astrid Fleckenstein Daniel Weickenmeier Zoé Zimmermann Cologne

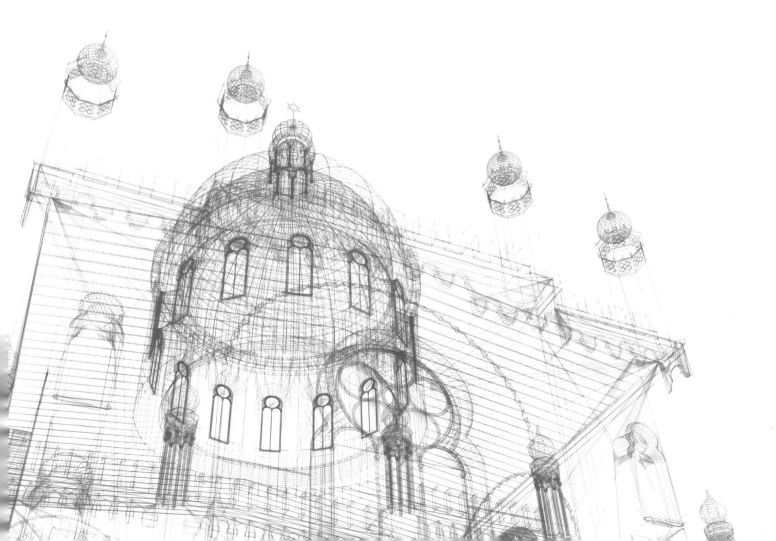

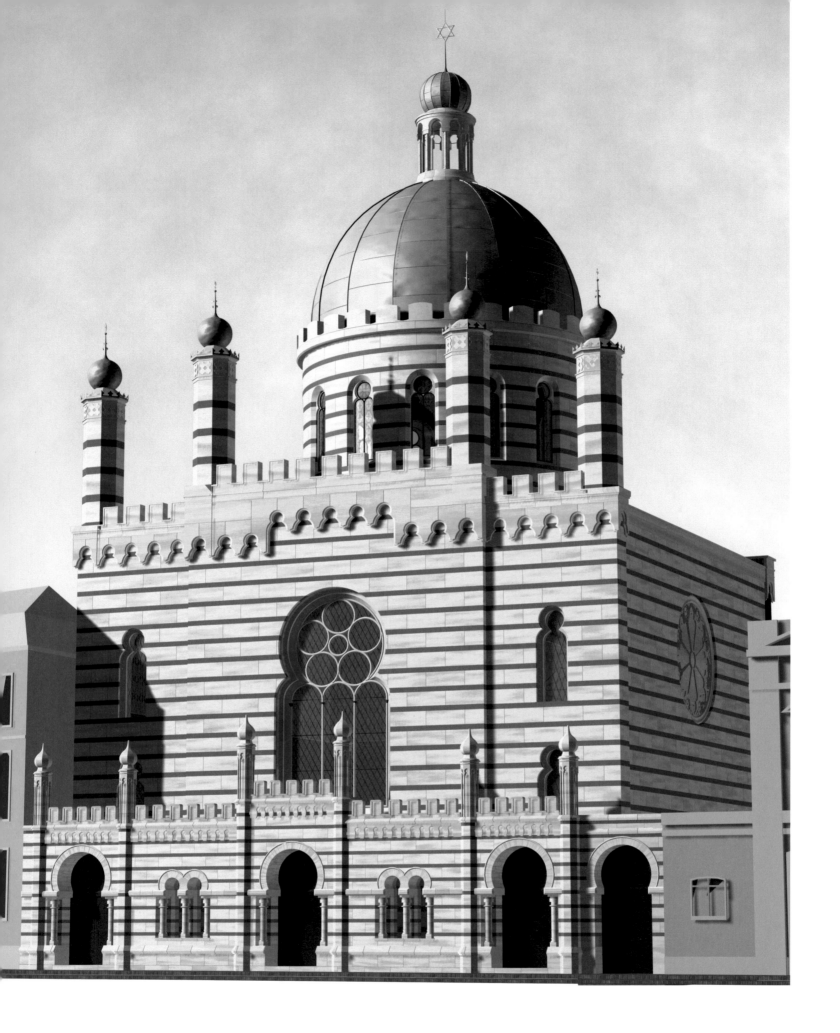

left page: Front view

right: Details of the front of the building

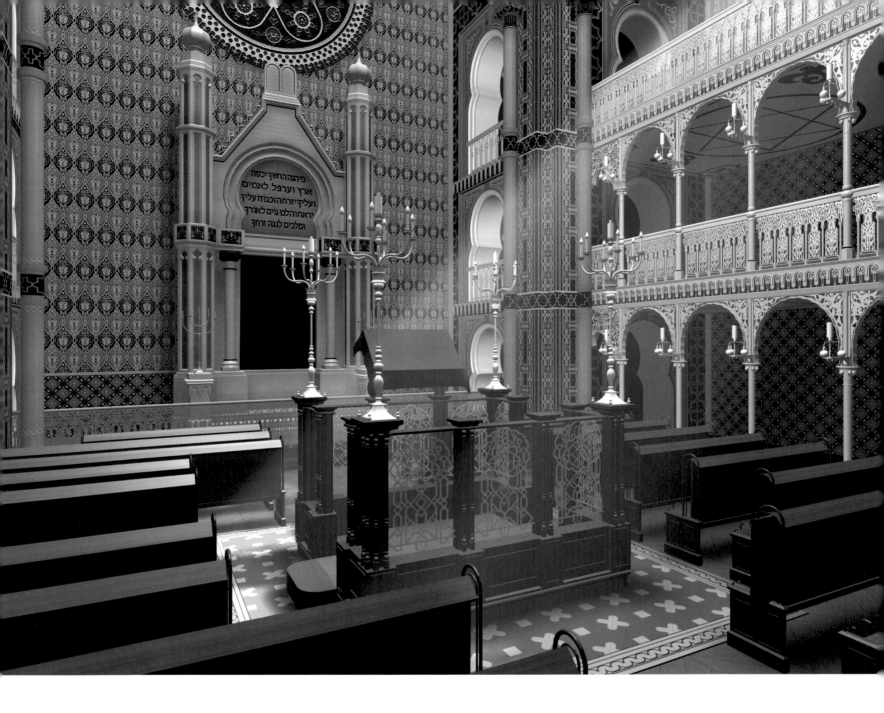

left page: View of the bimah and Aron ha-Kodesh

left: View from the north aisle
right: View from the women's gallery on the second floor to the Aron ha-Kodesh

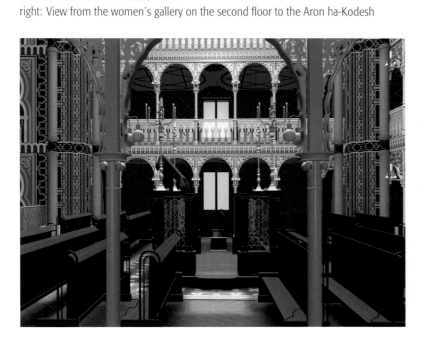

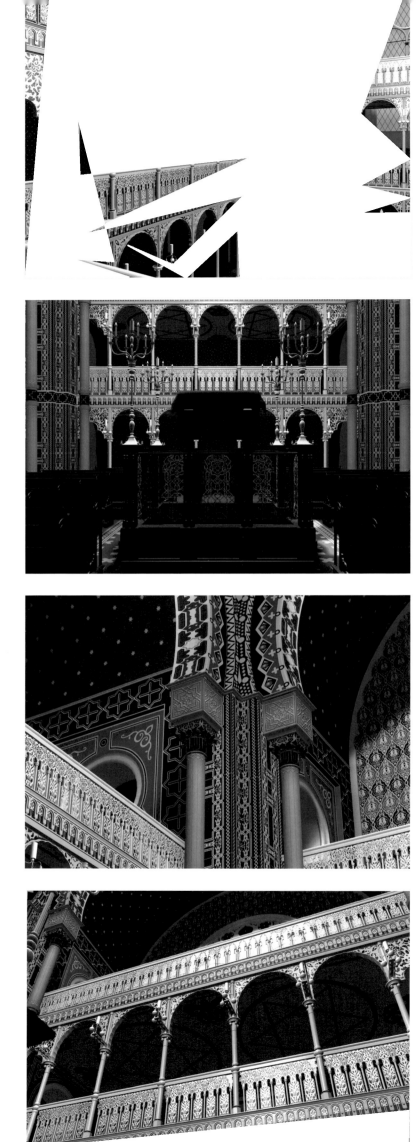

from top to bottom:
View from the first floor of the women´s gallery
of the opposite galleries
View of the bimah
Details of the pillars
Details of the women´s gallery

right page: Looking up into the dome

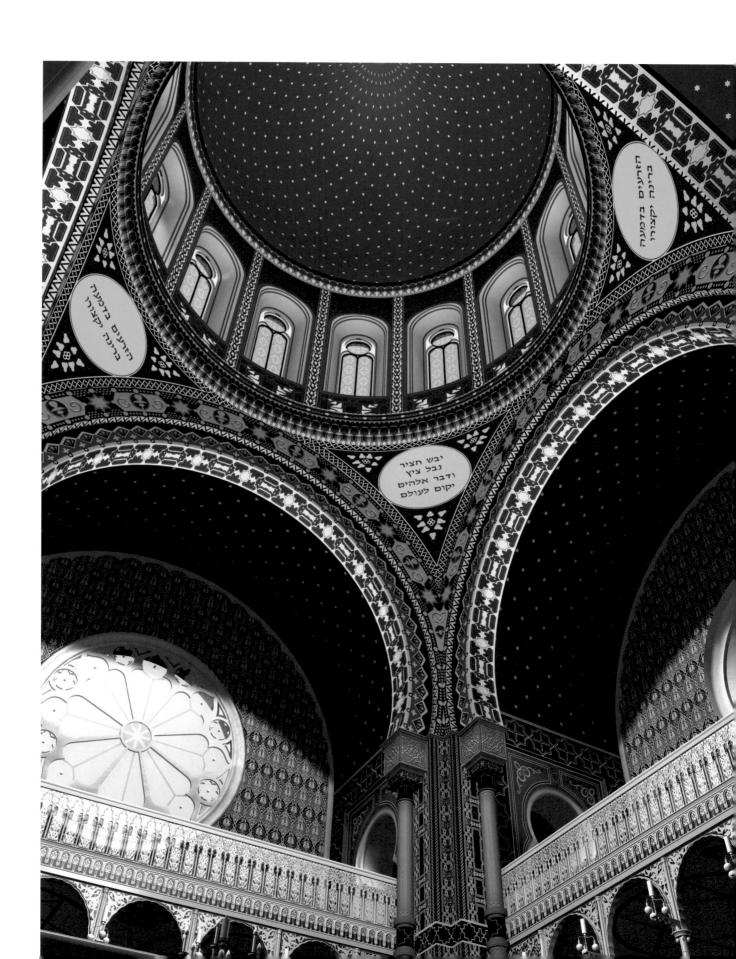

Dortmund

Hiltropwall, 1900 – October 3, 1938

The architect Eduard Fürstenau was commissioned to build the new synagogue on Hiltropwall after winning the competition held by the Jewish community of Dortmund. The synagogue, which was consecrated on June 6, 1900, cannot be clearly assigned to a particular architectural style.

The synagogue was a massive stone structure incorporating elements of Renaissance style with details strongly reminiscent of the late Gothic as well as regional Westphalian architectural forms. It can be assumed that, when choosing the style, the Dortmund Jewish congregation had in mind the post office across the street, which had the late Gothic elements that were very common in Germany during the reign of Kaiser Wilhelm II. The synagogue was a freestanding building on a corner lot in the center of the city. Its floor plan was based on a square, with corner towers at the four points of the diagonals and a dome covering the center section. Four columns supported the interior prayer hall, which was 22 meters high, giving it a great sense of spaciousness and transparency. The Dortmund synagogue seated 750 men on the ground floor and 450 women and 70 choir members in the galleries.

Under pressure from the NSDAP (Nationalsozialistische Deutsche Arbeiterpartei; the National Socialist German Workers' Party), the Jewish congregation was forced to transfer ownership of the synagogue building and property to the city of Dortmund in September 1938. Soon thereafter, demolition work began. On October 19, the main building was blown up; after several more explosions, the synagogue's demolition was complete on December 30, 1938. While the Jewish congregation in Dortmund had about 4,200 members in 1933, by August 1945 it had only 40 to 50 members. In 1997 there were again 2,720 members.

Today, the city theater and its forecourt occupy the site of the former synagogue. A bronze plaque and a memorial stone call to mind the events of the National Socialist regime.

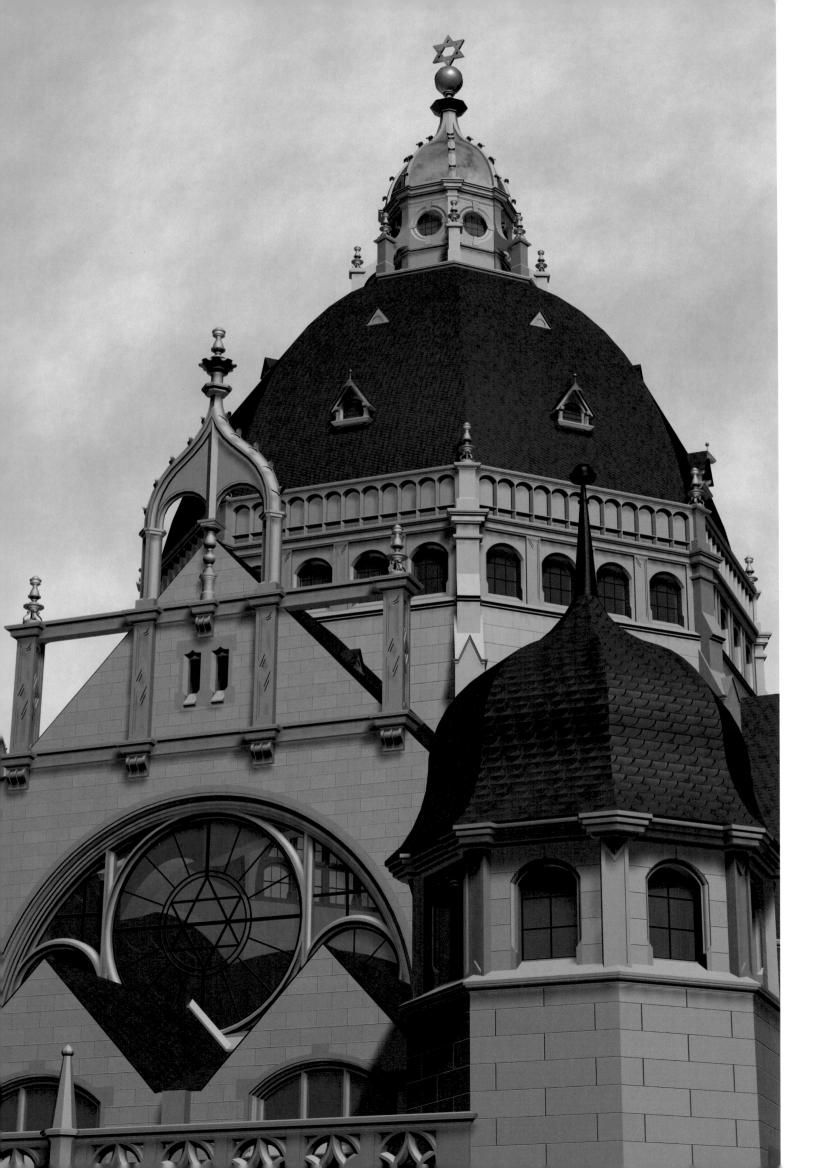

left page: View of the west façade and dome

bottom: View of the entire building

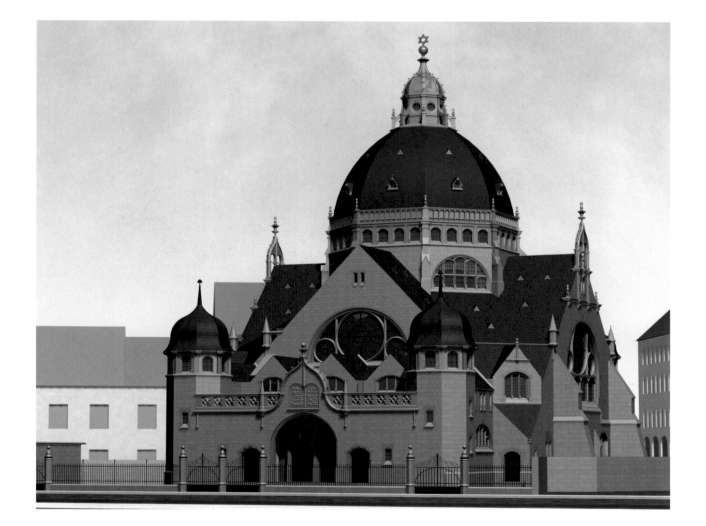

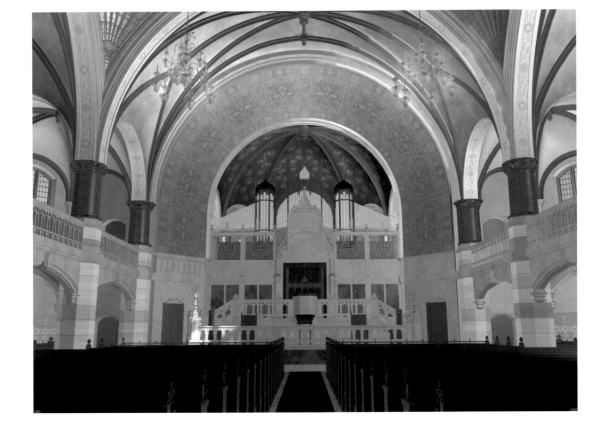

left page top: View of the west gallery
bottom: View from the entrance of the Aron ha-Kodesh

top: Looking up into the dome

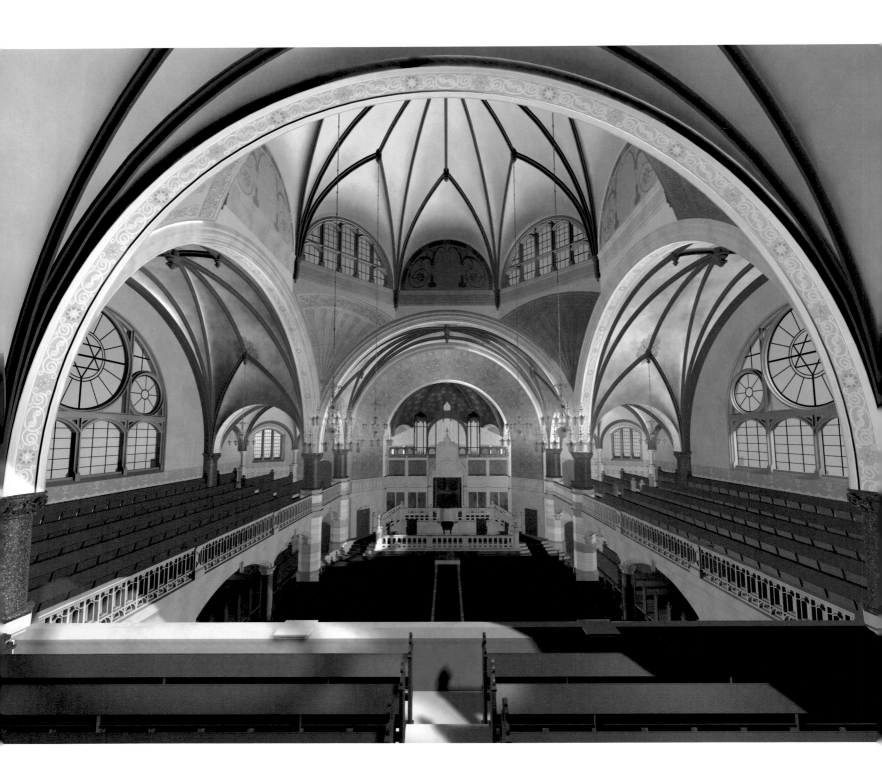

top: View from the west gallery

right page top: View from the dome
bottom: View from the south women´s gallery of the Aron ha-Kodesh and bimah

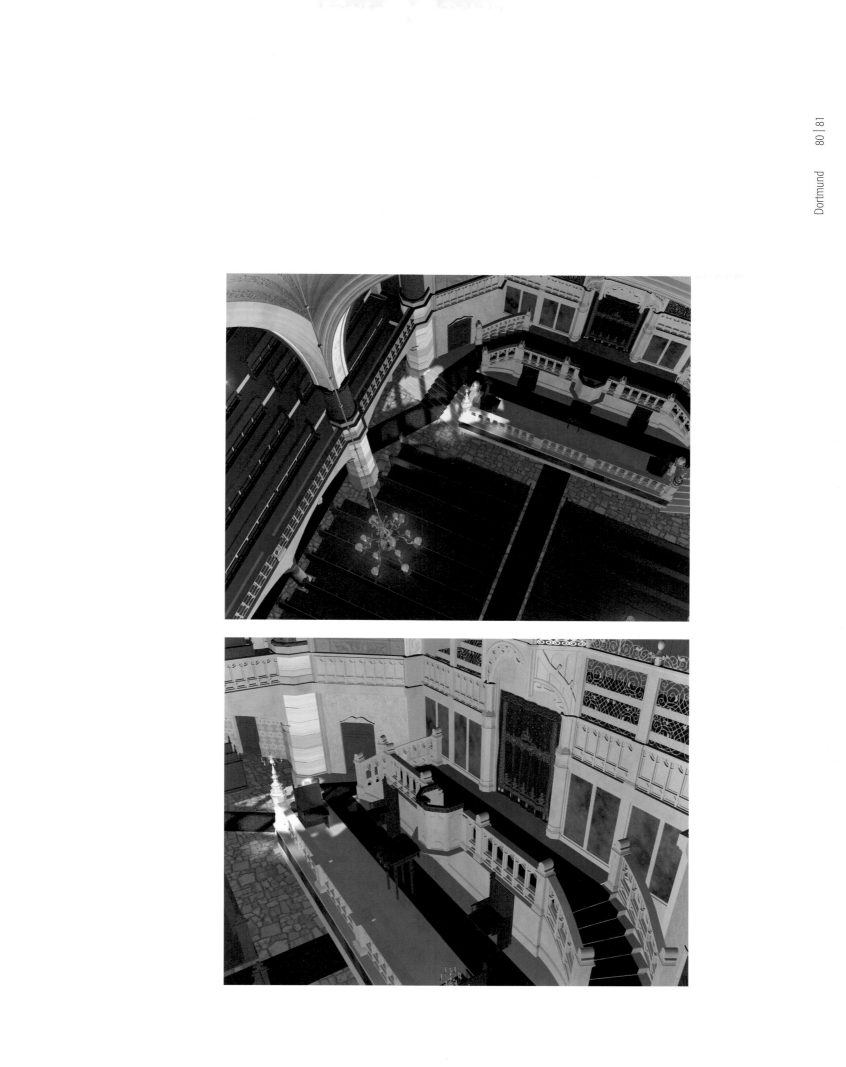

Dresden

Dresden

Zeughausstrasse, 1840 – November 9 – 10, 1938

In 1838 the 682 members of the Jewish congrega-
tion, who previously had attended four private
synagogues, were granted the right to establish a
common house of worship. After long negoti-
ations with the government about the site, the con-
gregation decided to purchase property at
Gondelhafen on the Elbe River in the northeastern
part of the old city. This was not the suitably
representative location they had been seeking.
However, they were able to commission one
of the most renowned architects in Germany,
Gottfried Semper, professor of architecture at
the Royal Academy of Arts in Dresden.

On May 8, 1840, the synagogue was consecrated. It
was a comparatively simple and straightforward
central-plan building crowned by a raised octagonal
tower; there were also two towers on the vestibule
to the west. The exterior was influenced by Roman-
esque architecture whereas the interior was
Moorish in style. The square prayer hall with its
two-storied galleries seated 300 men and 200
women and also had standing room for 500 persons.
At the east end of the synagogue, elevated a few
steps above the ground floor, were the bimah and
the Torah ark.

The public anti-Jewish campaign of terror began the
night of November 9-10, 1938, with a rally in
front of the city hall. The first deportation followed:
151 predominantly wealthy and prominent
Jewish citizens of Dresden were taken to the Buchen-
wald concentration camp. That night, the syna-
gogue was set on fire. The Jewish congregation
itself had to bear the costs of clearing the rubble.
Before the last planned deportation in February 1945
(which was not carried out) 174 Jewish citizens
still lived in Dresden.

Since 1973 a commemorative stone designed by
Friedmann Döhner serves as a reminder of the
synagogue. Since the urban geography is completely
different now, the stone is not located where
the synagogue once stood.

bottom from left to right:
View of the dome
View of the front towers
Details of the front tower

right page top: View of the entire building

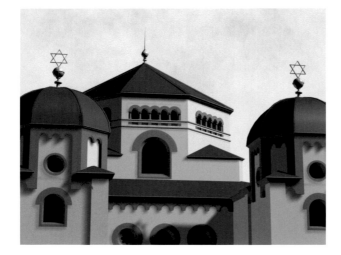

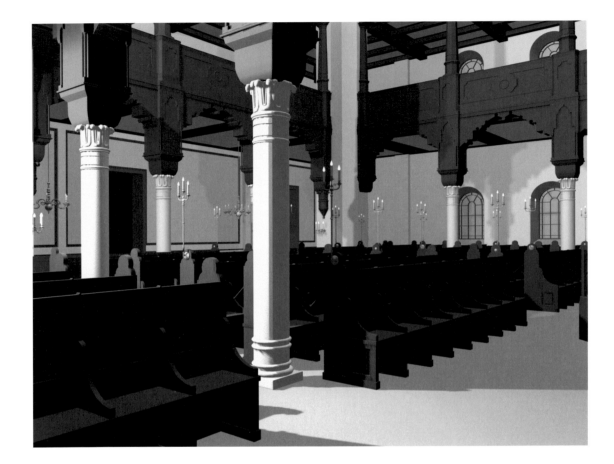

top: View of the entrance and north wall

right page left: View from the aisle
right: View from the entrance of the Aron ha-Kodesh

Frankfurt / Main

Frankfurt /Main

Judengasse, 1860 – November 9 –10, 1938

In the 19th century, when the structural condition of the old Hauptsynagogue (main synagogue) became more and more deteriorated and the crowded premises no longer met the congregation's needs, plans for a new building were taken into consideration. On June 18, 1858, the cornerstone of the synagogue, designed by the architect Johann Georg Kayser, was laid; the dedication ceremony took place on March 23, 1860. The building had 594 seats for men on the ground floor and 506 seats for women in the galleries of the two upper floors.

The Hauptsynagogue, built of red Main River sandstone, was characterized by a mixture of oriental and Gothic architectural elements and reflected the new self-confidence of the Jewish congregation. Presumably, the architect chose elements giving an oriental impression in view of the historic origin of the Jewish religion. The Gothic elements, on the other hand, manifested the ties to the German nation.

The interior was greatly influenced by the horseshoe arch. The floor plan indicates that the congregation as a whole was in favor of reform. The bimah, where the Torah scrolls were read, was not traditionally located in the center of the synagogue but rather opposite the main entrance (analogous to the position of the altar in churches). This reference to Christian ecclesiastical architecture was again underlined by the placement of a pulpit near the ark and an organ in the choir loft.

Today a municipal building is located on the site of the former synagogue.

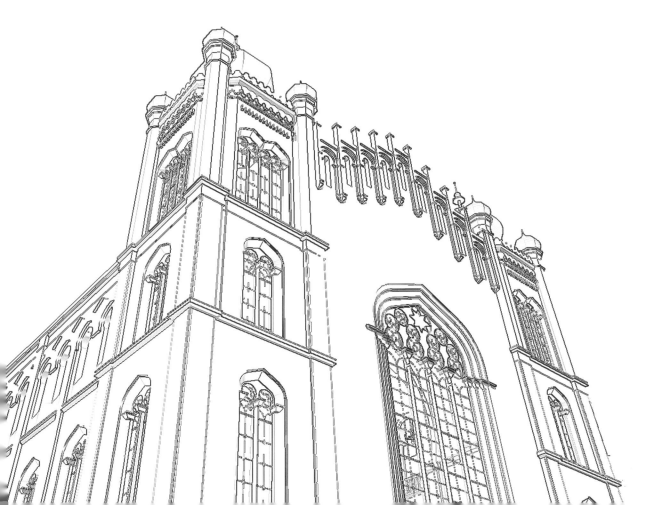

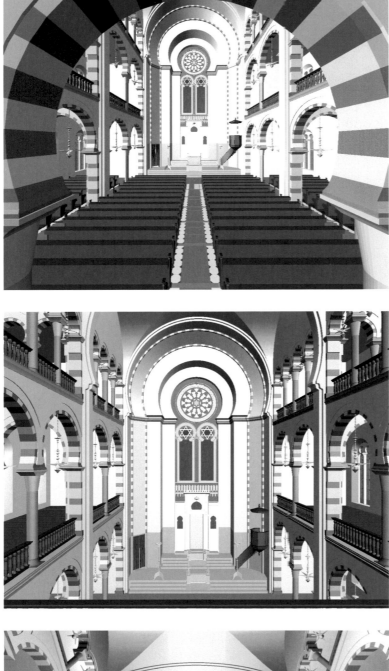
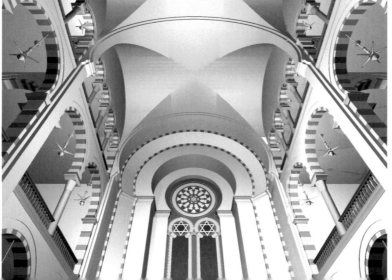

left page top: Horseshoe arch
middle: View from the west gallery
bottom: View of the main vault

top: Chandelier

Frankfurt / Main

Frankfurt / Main

Börneplatz, 1882 – November 9 – 10, 1938

The Börneplatz synagogue was built in 1882 on the Judenmarkt, later called Börneplatz, next to the old Jewish cemetery. The exterior of the building was characterized by elements of Italian Renaissance architecture and by the red color of the Main River sandstone. The building calls to mind secular buildings such as banks, private residences or villas, whose staircase turrets were particularly popular at the time. This type of building was selected in order to avoid any resemblance to Christian ecclesiastical architecture. The interior corresponded to the central room used for the orthodox Jewish service. However, it was altered to allow for a "powerful development of the torah shrine apse." The available photographs of the interior show only one perspective of the apse from the main entrance.

On November 10, 1938 the Börneplatz Synagogue was set on fire. Months later the debris was removed by the Jewish congregation at their cost.

After the war, a filling station and a wholesale flower market were built on the site of the former synagogue. In 1987 part of the foundation walls of the synagogue as well as those of the former ghetto were exposed during the excavation work for a municipal administration building. In spite of protests, the building was erected. The foundation walls of five houses were integrated into a small museum in the new building.

Today the outline of the former synagogue can be found on the concrete sidewalk of Neue Börneplatz; since 1996 it has been part of a memorial to Frankfurt's former Jewish citizens who were victims of the Holocaust.

top: Bimah with view of the Aron ha-Kodesh

right page top: View from the women´s gallery
midd e: View from the apse
bottom: View of the vault of the apse

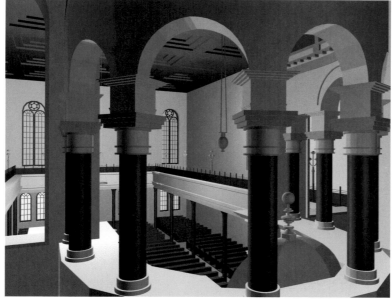

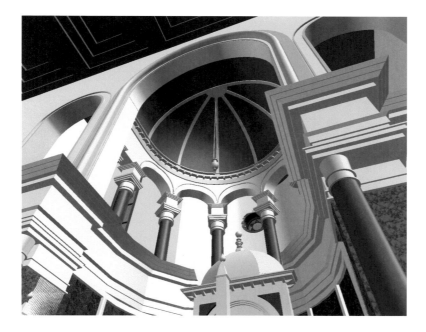

Frankfurt / Main

Frankfurt / Main

Friedberger Anlage, 1907 – November 9 – 10, 1938

Peter Gallenz Nadine Paraton

The synagogue on the Friedberger Anlage was built in 1907. It was the largest synagogue in Frankfurt, the successor to the first orthodox synagogue founded in 1876. A considerable increase in the membership of the congregation around the turn of the century resulted in the need for a larger synagogue, one that could seat at least 1,000 men, 600 women and 60 choir members. Further important prerequisites for the construction of this austere orthodox synagogue were: separate entrances for men and women, a gallery for women, an interior room three steps lower than ground-floor level, the central position of the bimah, and the high positioning of the windows so that worshippers would not become distracted.

The architectural style was based upon the Art Nouveau trend of the time. This was particularly evident in the west façade and the side towers. Only a few historical (Romanesque) elements were used. The prerequisites stipulated that "foreign styles" and "conspicuous elements" were to be avoided. Barrel vaulting was the predominant feature of the interior. According to eyewitnesses, the soft colors and ingenious lighting, as well as the discreet use of ornamentation, created a befitting atmosphere.

In the pogrom night of November 9 to 10, 1938, the synagogue on the Friedberger Anlage was destroyed. Soon after, on November 17, demolition was begun. In 1943 an air raid shelter was built on the former site of the synagogue. Today there is a small memorial in front of the shelter.

Of the four large Frankfurt synagogues, the three buildings shown here were totally destroyed as a result of the Reichspogromnacht. Before 1933, over 30,000 Jews lived in Frankfurt; 20,000 of them were able to flee Germany, but more than 11,000 were murdered by the National Socialists. After the war a new Jewish congregation was formed, which is again among the largest in Germany.

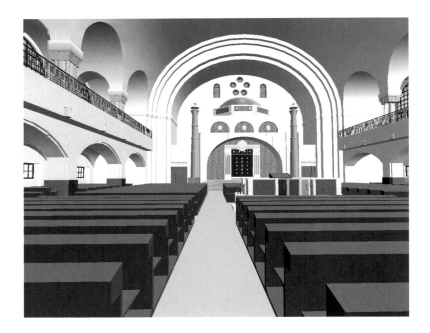

left page top: View from the women´s gallery

bottom from left to right:
View from the entrance of the Aron ha-Kodesh
View from the aisle
View of the women´s gallery

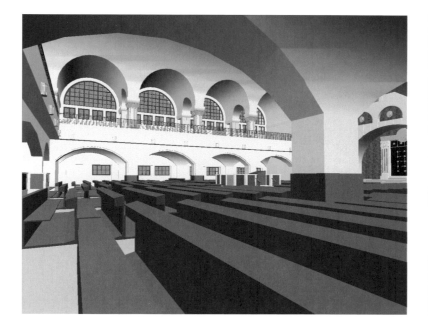

Hanover

Hanover

Bergstrasse, 1870 – November 9, 1938

In 1862 the Jewish congregation of Hanover, which had 1,100 members, commissioned the Jewish architect Edwin Oppler to design a new synagogue. Erected between 1864 and 1870, Oppler's huge domed synagogue covered 850 square meters and had seating for 1,100 persons. Unlike most other synagogues – societal pressure and the congregation's own misgivings usually worked against a decision for a prominent city location – this synagogue was located on an open square as a freestanding structure with four ornate façades. Oppler chose a neo-Romanesque style for the building: "Roman-esque style is German through and through and if the structure is to claim that it is monumental, then it must, above all, be in a national style." (Stu-dien, August 5, 1863) The square-shaped floor plan of the main hall with the bimah located below the dome emphasized the communal character of Judaism. Nonetheless, the lengthwise galleries, which seated 450 women, and the view toward the magnificent Holy Ark gave the room a definite orientation from west to east. The mighty dome at the crossing dominated the interior and there was ornamentation throughout the interior.

The synagogue was consecrated with a religious service on September 15, 1870, and served as a house of worship for almost seven decades until it was destroyed on November 9, 1938. The congregation's membership declined from 4,839 in 1933 to only 285 in 1944. Today a memorial plaque calls to mind the events of the past with an inscription from the Book of Jeremiah, Chapter 8, Verse 23: "Oh that my eyes were a fountain of tears that I might weep day and night for the slain of my people." In the 1960s, the 434 members of the postwar Jewish community built a new synagogue on Haeckelstrasse.

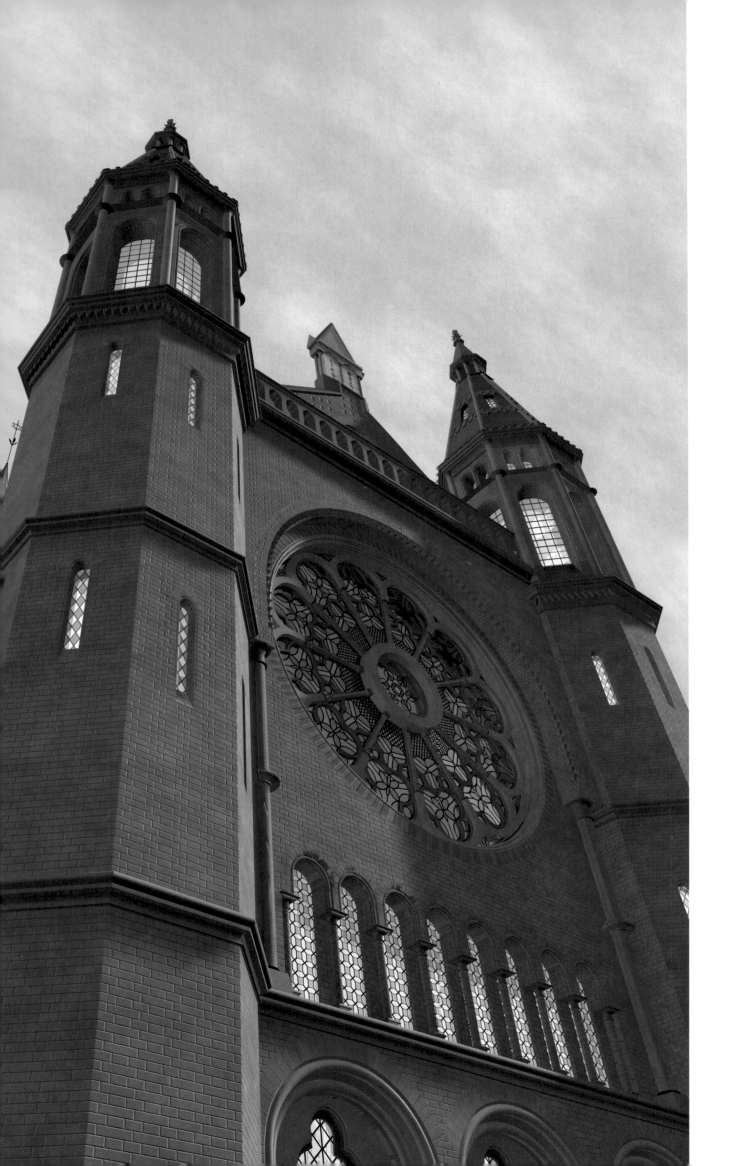

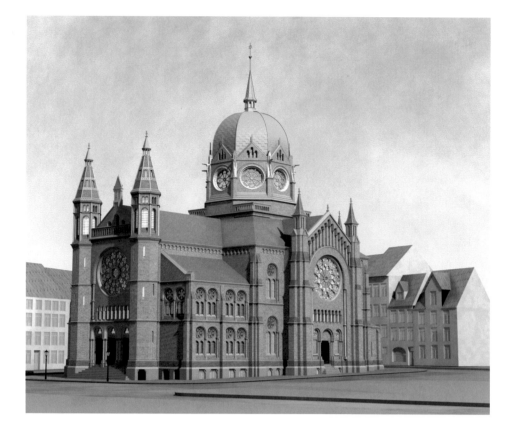

left page: Front with rosette

top: View of the entire building
bottom: Details of the south façade

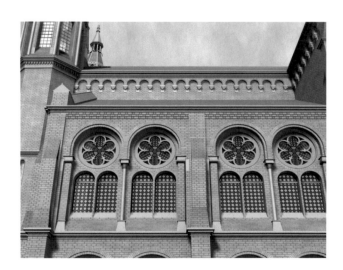

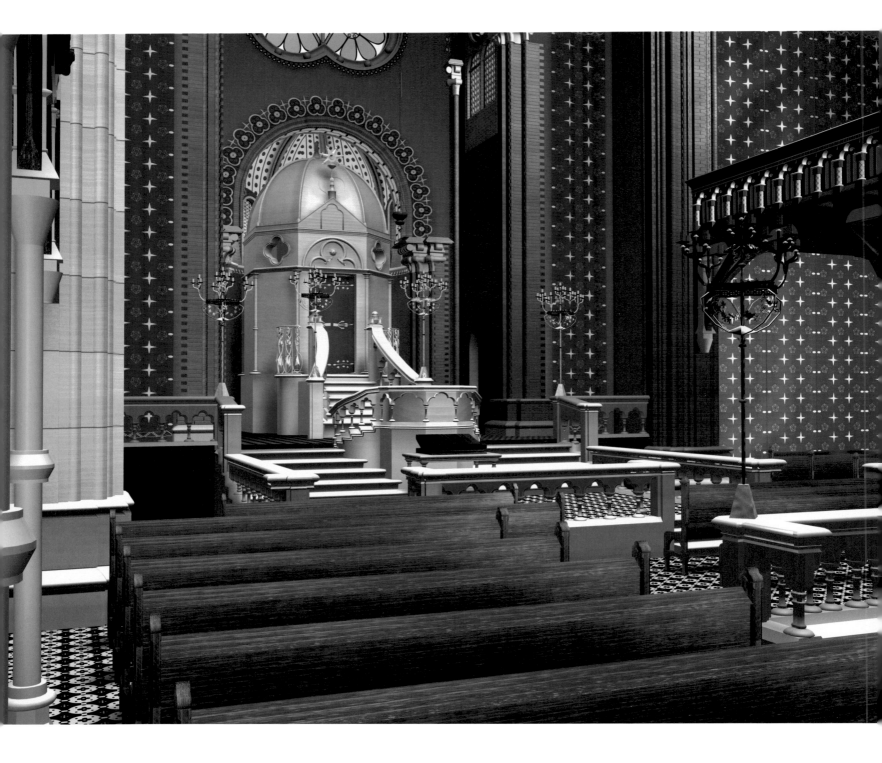

top: View of the Aron ha-Kodesh

right page: View of the women´s gallery

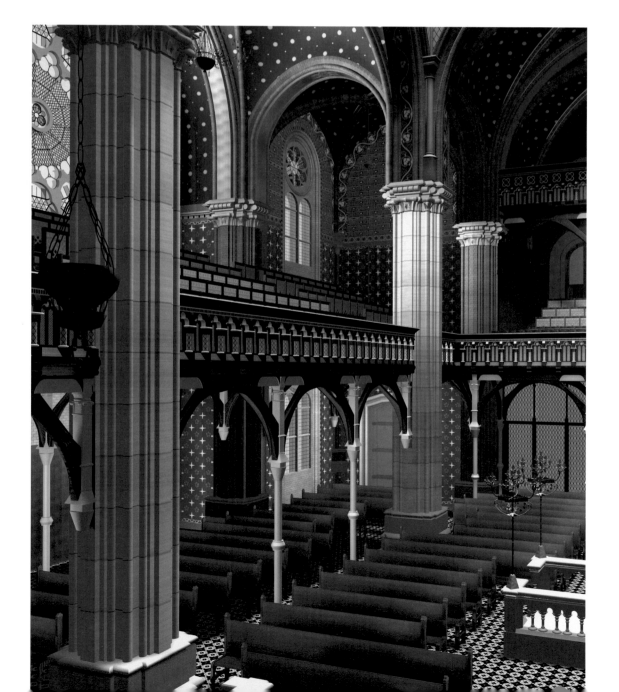

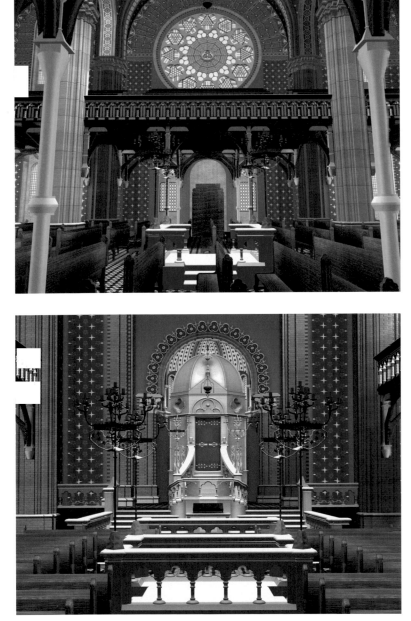

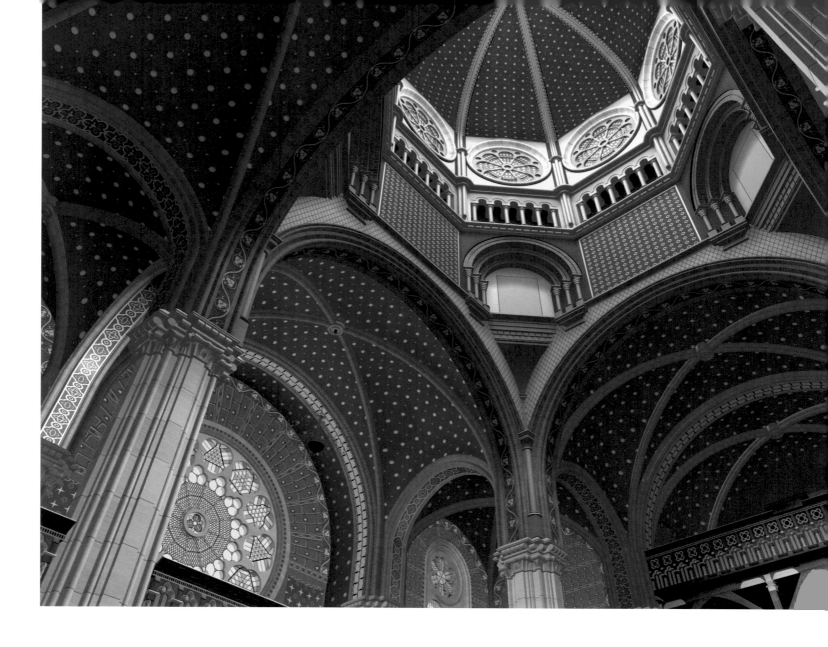

left page top: View from the north aisle of the bimah
middle: View of the bimah and the Aron ha-Kodesh
bottom: View from the north women´s gallery of the west gallery

top: Looking up into the dome

Kaiserslautern

Luisenstrasse, 1886 – August 31, 1938

Consecrated on February 26, 1886, for 52 years this house of worship was considered to be the most important synagogue in the Palatinate (a district in southwest Germany west of the Rhine). The Jewish architect Ludwig Levy designed the imposing structure, which with its prominent central location and central-plan design made a great impact on the cityscape of Kaiserslautern.

The style of this synagogue was Moorish-Byzantine. Its main distinguishing feature was the central cupola which, with the four smaller cupolas on the corner towers, emphasized the central-plan character of the building. The prayer hall had three aisles. At the western end was a gallery with the organ and to the east, the room was completed by a chancel-like arrangement around the ark. Four steps led up to the bimah; from there, three more steps led to the Holy of Holies and the pulpit. The synagogue had 620 seats, 420 for men and 200 for women in the women's galleries. By 1933 the congregation had grown to 738 members. In 1945 there were less than 25 of them.

The synagogue had already been demolished before the Reichspogromnacht. In July 1938, it was announced that the synagogue no longer fit into the cityscape and that the grounds would be used for party rallies. The last religious service was held on August 27, 1938. On August 31, 1938, demolition began. A quote from the August 29, 1938, edition of the NSZ-Rheinfront, the daily newspaper of the National Socialist party, read: "A bit of the Orient disappears. This joyful news hit like a bombshell...". However, no rallies ever took place on the site of the former synagogue. Instead, an air raid bunker was built on the property during the war.

On October 8, 1980 – 42 years after the building was blown up – the place where the synagogue had stood was officially renamed "Synagogenplatz" (Synagogue Square) In 2003, part of the northern arch was reconstructed; it suggests the size and substance of the synagogue that once stood here. Hedges further outline the ground plan of the former building.

Daniela Georgescu Adrian Mnich Heidrun Rau Alexander Schmid

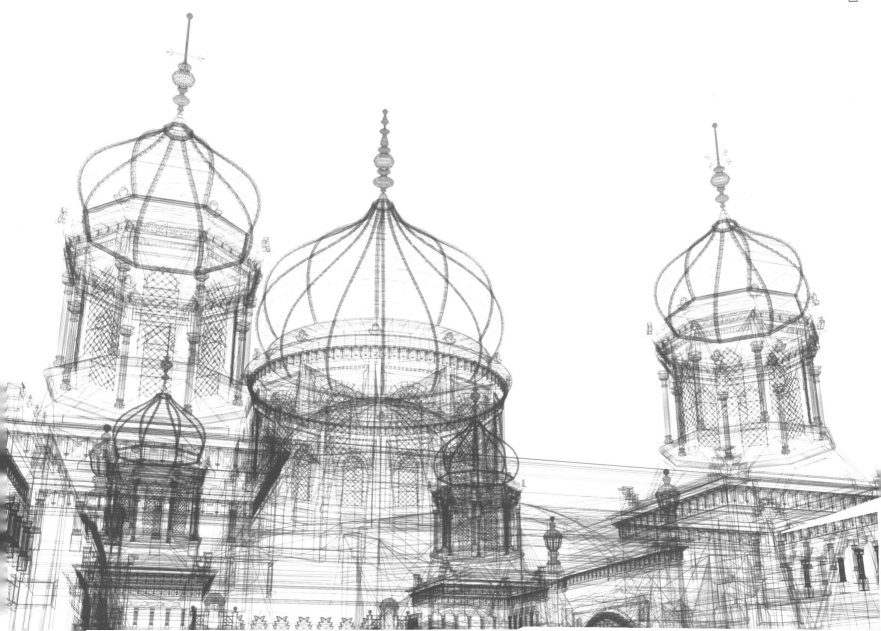

left: View of the entire building
right: View of the cupolas and dome from the southwest

right page: View from the street leading to the entrance of the synagogue

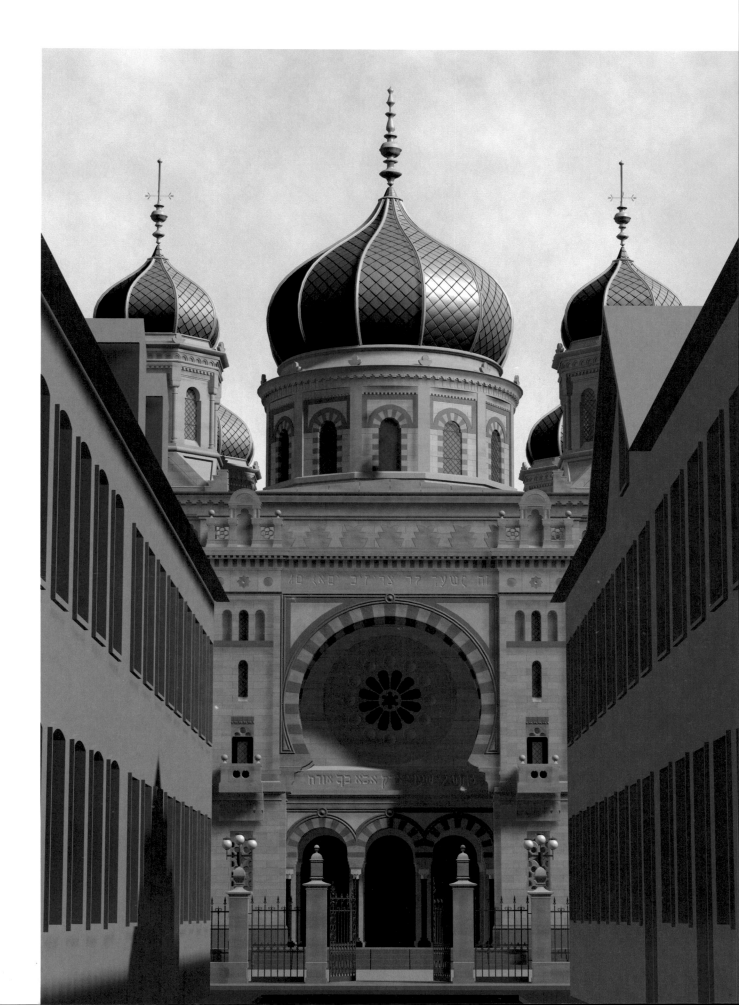

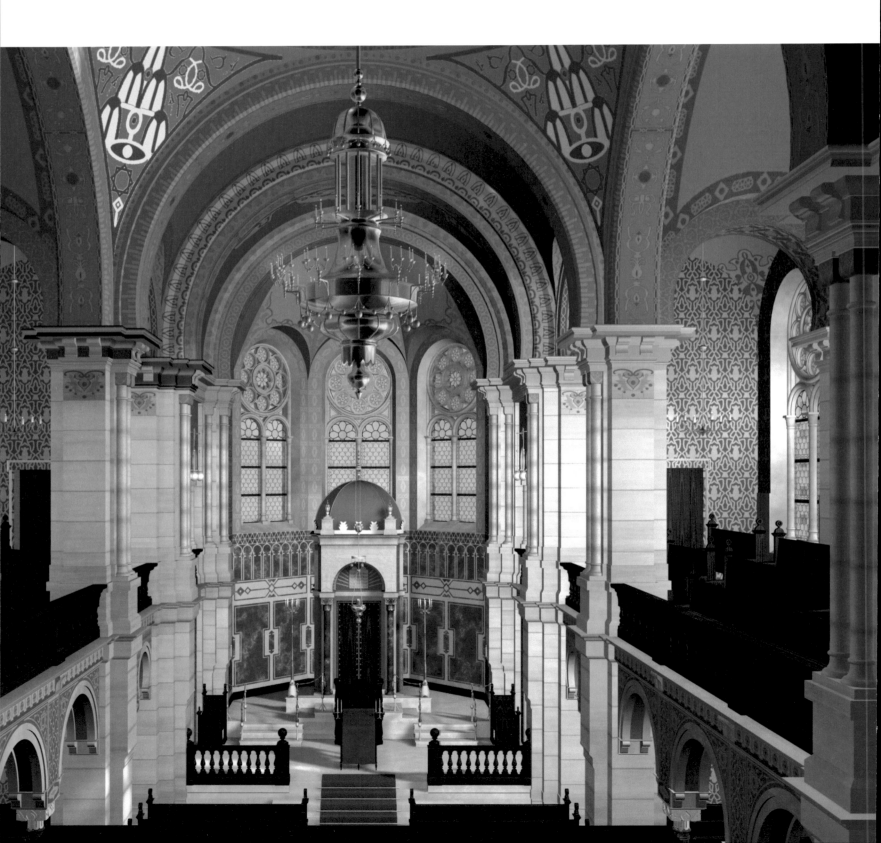

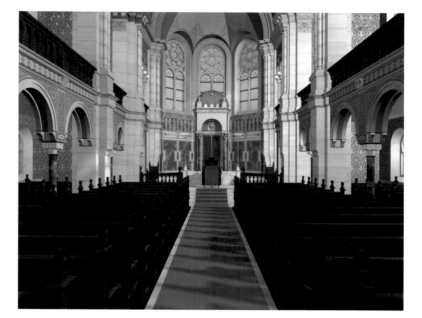

left page: View from the west gallery of the Aron ha-Kodesh

top: View from the bimah to the organ
bottom: View from the entrance of the Aron ha-Kodesh

left page: View from the dome

top: View of the Aron ha-Kodesh and the bimah
bottom: View of the south aisle

Leipzig

Leipzig

Gottschedstrasse/corner Zentralstrasse,
1855 – November 9–10, 1938

Today on the site of the former synagogue there is a memorial stone and a large memorial which traces the outlines of the synagogue. Within the outlines are dozens of rows of empty bronze chairs, representing the place where the men once had prayed.

The memorial stone commemorates what was once the city's largest Jewish house of worship, consecrated on this site on September 10, 1855. The liberal congregation, which had only 81 members at the time, commissioned Otto Simonson, a pupil of the renowned architect Gottfried Semper, to build the synagogue. The trade fair city of Leipzig attracted many Jews, who first organized a number of small prayer houses to pursue their varied religious practices. In order to unite them all, plans were made for a "general" synagogue for 2,000 persons, with at least 1,200 seats.

Otto Simonson was given no restrictions on the design. However, available funds were limited and the form of the site was angular. The latter led to the unusual triangular floor plan of the synagogue proper, not including the annex. The focus of the building was the Holy of Holies, which was placed at the eastern apex where two streets came together. From this point, an axis dividing the property into two equal sections was the framework for Simonson's nearly symmetrical construction.

To set off the structure from the neighboring buildings, Simonson decided to use the Moorish style. This was displayed in both the horseshoe arches and mighty blind arcades of the exterior as well as in the basket arch-like arcades and the repetition of the horseshoe arch motif in the interior.

Until the night of November 9, 1938, when the Nazis set fire to the building, the synagogue served the growing community. In 1925 there were over 13,000 citizens of Jewish faith in Leipzig and the surrounding area. In 1945 fewer than 300 Jews had to build a new life.

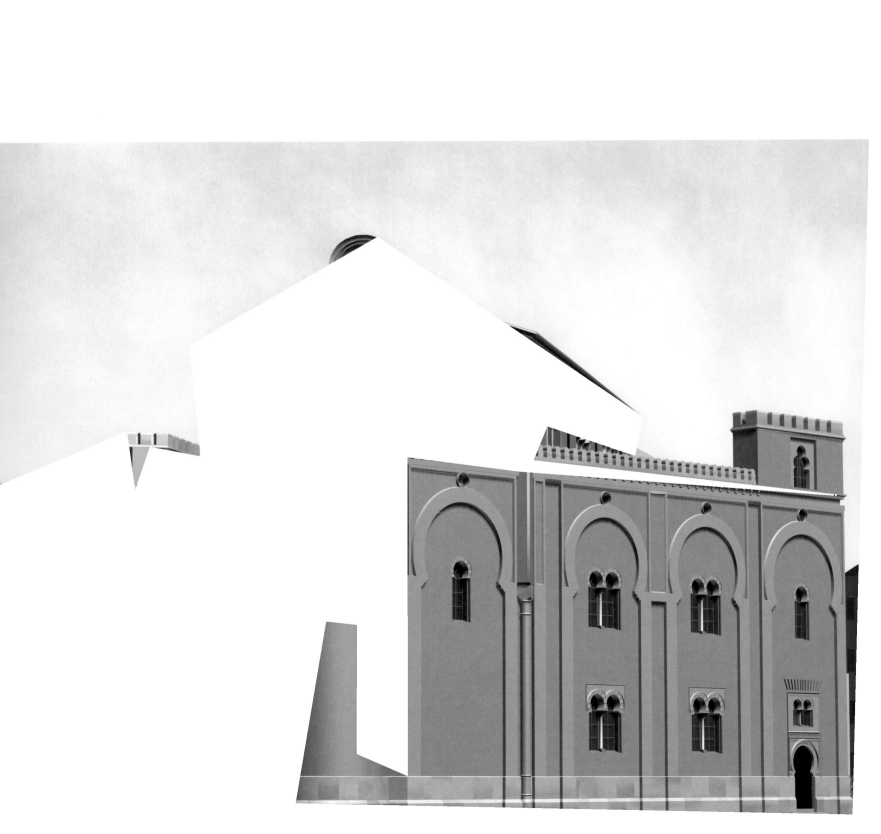

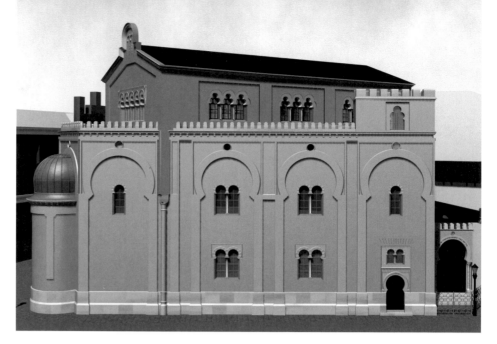

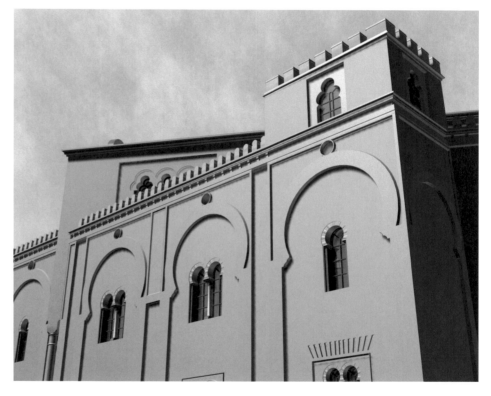

left page: View of the entire building

top: Frontview
middle: View of the north façade
bottom: View of the apse

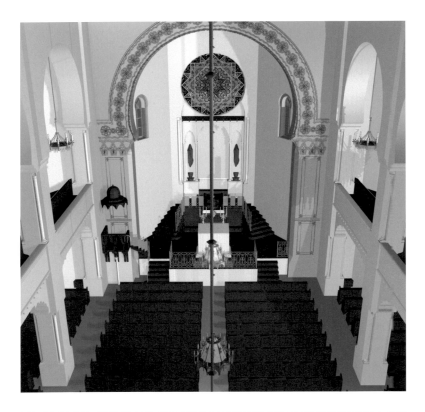

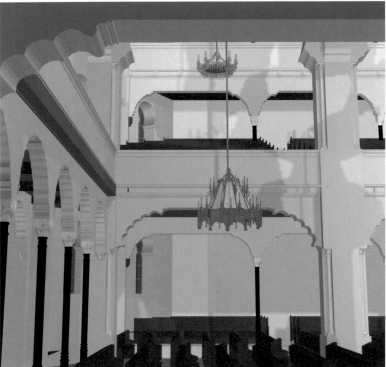

top: View from the vault
bottom: View from the aisle

right page: View from the entrance of the Aron ha-Kodesh

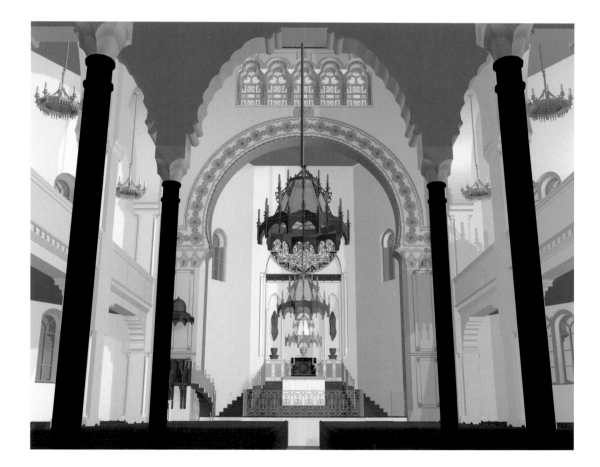

Mannheim

F2,13*, 1855 – November 10, 1938

Since the middle of the 17th century there has been a Jewish community in Mannheim. Its first synagogue was located on the property F2,13 – at that time, the Wormser Gasse. After tearing down the city's first Jewish house of worship, the congregation erected a new synagogue on the site. The architect Ludwig Lendorff designed the building and, after four years of construction, the synagogue was consecrated on June 29, 1855. Unlike the old synagogue, it was not hidden within a courtyard. Instead, it had a grand imposing street façade that towered above the neighboring small one- and two-story buildings.

This new main synagogue in Mannheim was built for the liberal Reform congregation. The conservative orthodox congregation attended the so-called Klaus Synagogue, which was located on F1,11. In accordance with the liberal liturgy, the new synagogue had an organ in the west gallery and in the east, near the Torah ark, an elevated pulpit on the southern side wall. The bimah was no longer located on a platform in the middle of the room, as was customary, but instead was placed, rather like an altar, directly under the pulpit in front of the ark. The aesthetic of this eastern part of the synagogue was strongly reminiscent of the chancel in a church. The only Judaic elements in the interior were the two tablets of Law crowning the ark and the Hebrew inscriptions. The Jewish assimilation of the 19th century was also reflected in the west façade. Architectural elements such as windows with round arches, the Romanesque entrance portal, Gothic window rosettes, and cross-shaped pinnacles resembled those of the Christian environment.

On November 10, 1938, the main synagogue was desecrated, ravaged and almost completely destroyed by the Nazis. However, the street façade, the perimeter walls and the arched arcades of the aisles survived World War II. These impressive architectural remains were taken down and removed in 1955/56. Thus one hundred years after its ceremonial consecration, the main synagogue in Mannheim finally disappeared from the cityscape.

An apartment building with a restaurant was constructed on its site. An inconspicuous plaque in the entryway of this new building is now the only reminder of the magnificent synagogue that once stood there.

After the liberation by Allied forces, the survivors of the Shoah founded a new Jewish community under the protection of the US Army in 1945. In 1946 they were able to erect a small community center with a prayer room in the former Jewish orphanage on R7,24. Then in 1957 the congregation moved to a newly built center with a small synagogue on Maximilianstrasse 6.

The Jewish congregation returned again to its old traditional location in the center of the city in 1987. On September 13, it was able to consecrate a large new community center and a beautiful synagogue on Rabbiner-Grünewald-Platz (F3). Although the congregation at present has only some 600 members and cannot be compared to the congregation before the Nazi time, when it had almost 7,000 members, it offers many cultural, social, and religious activities which are open to all citizens of the city and the country. Hence the Hebrew inscription over one of the entrance portals, which reads: "My house shall be called a house of prayer for all peoples!"

by David Kessler, Jewish Community of Mannheim

* The Mannheim city center is divided into squares identified by a combination of a letter and a number (from A to Z and from 1 to 7), e.g. F1, F2, F3 etc. Within a square the buildings or properties are numbered serially. So F2, 13 means square F2, building 13.

bottom: Front view

right page top: View of the rosette
bottom: View of the south façade

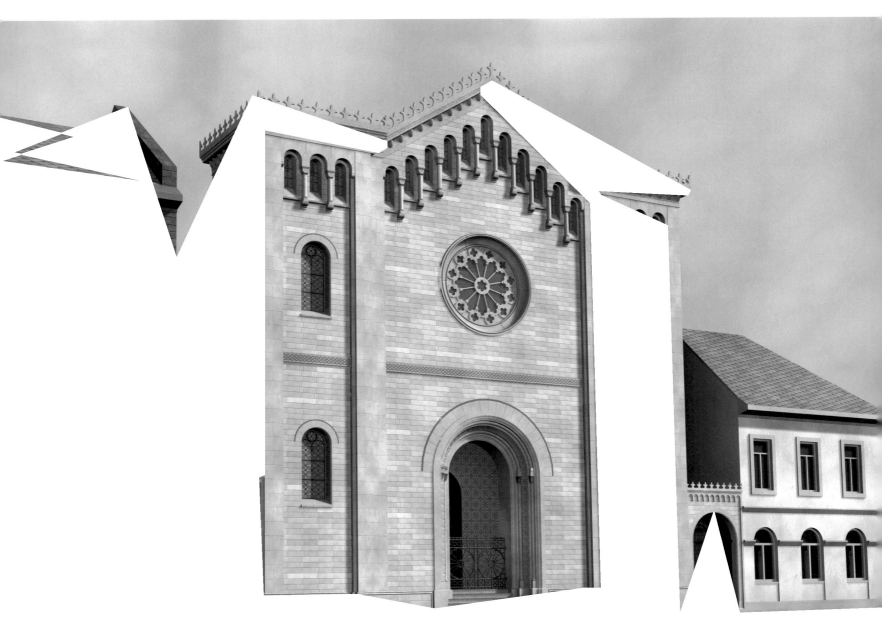

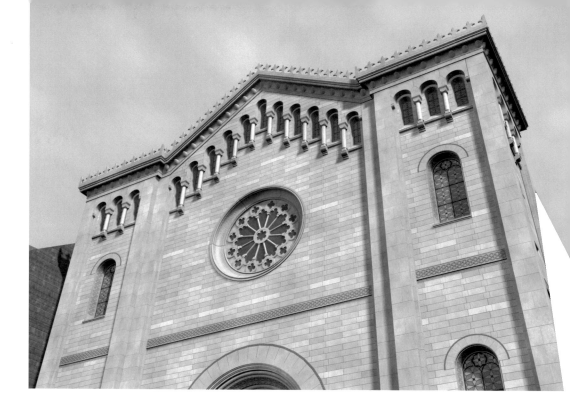
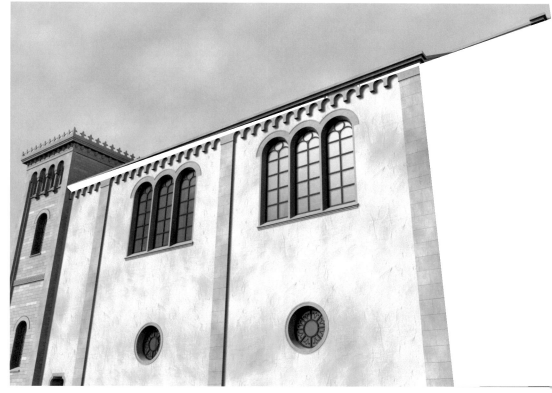

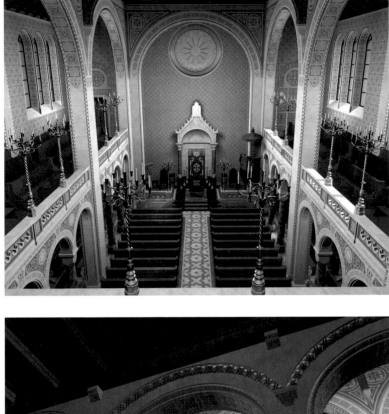

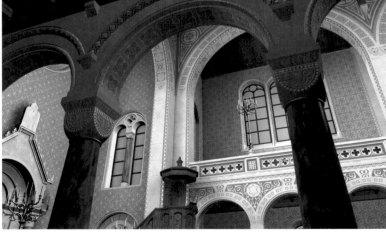

left page top: View from the west gallery of the Aron ha-Kodesh
middle: View from the north aisle
bottom: View from the north aisle of the entrance

left: View of the Aron ha-Kodesh
right: View of the pulpit

Illustration pp. 128/129: View from the entrance of the Aron ha-Kodesh

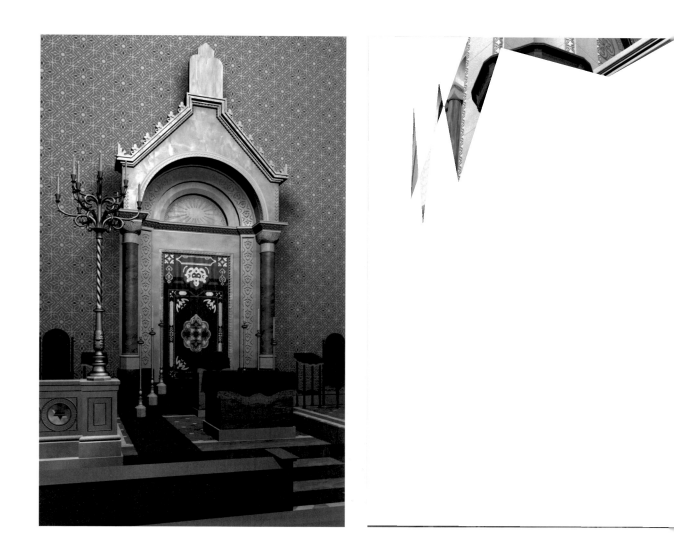

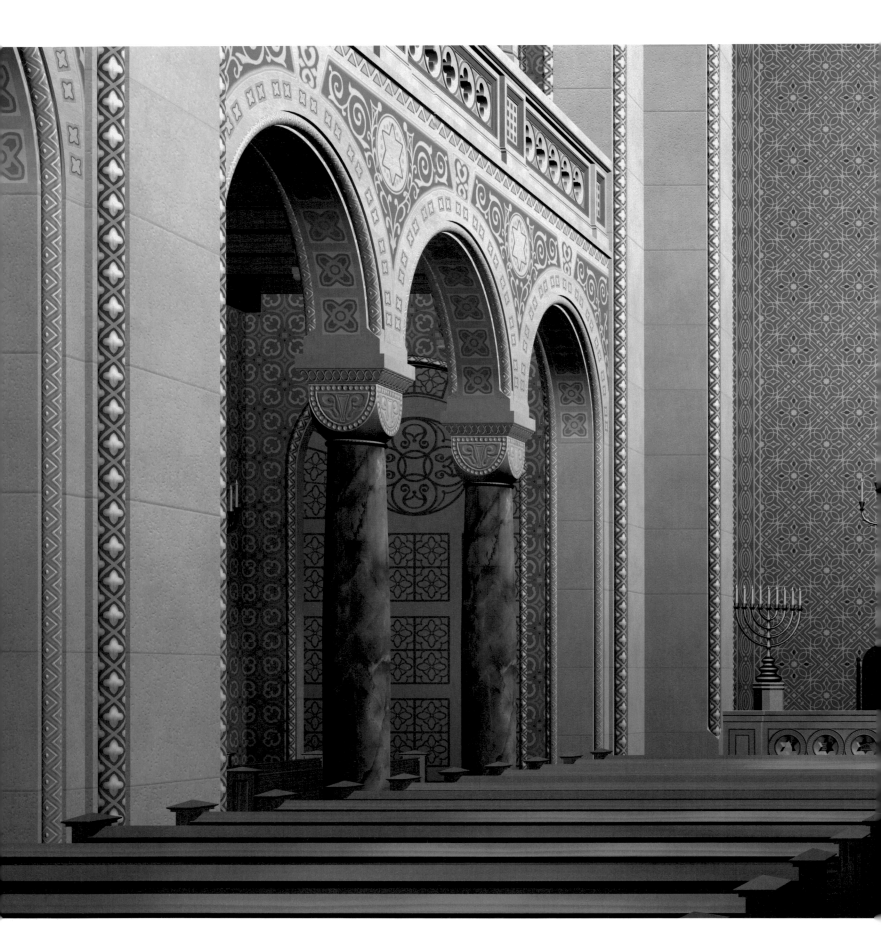

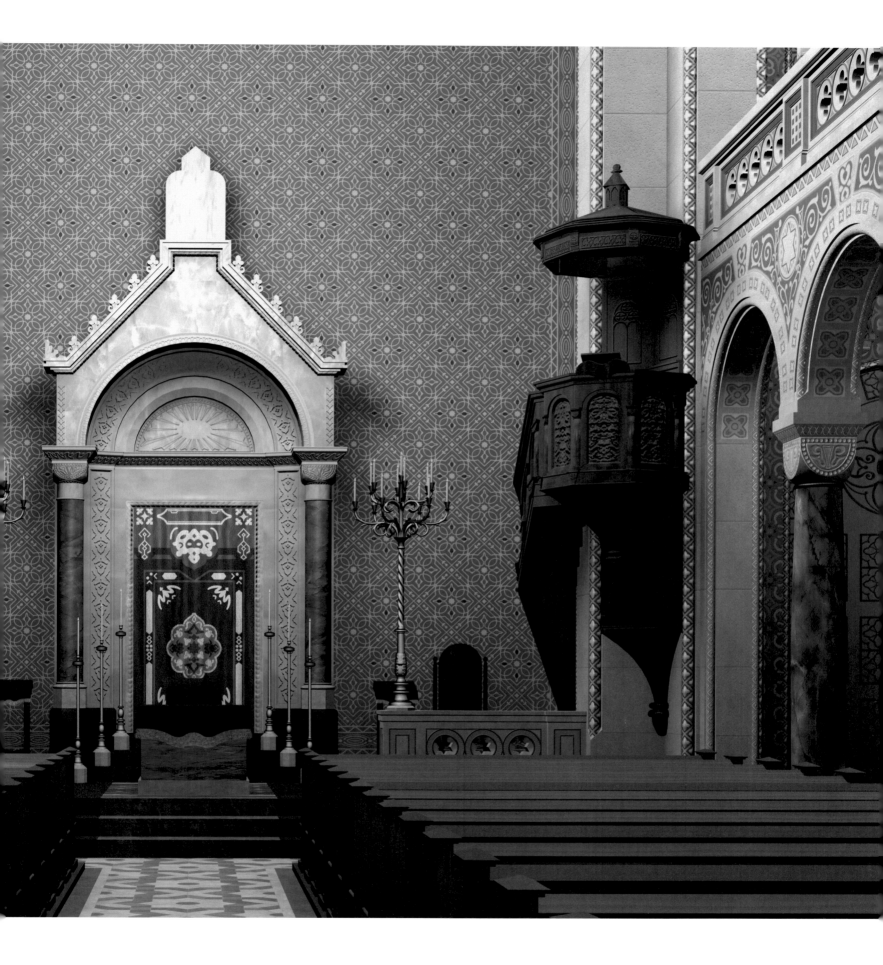

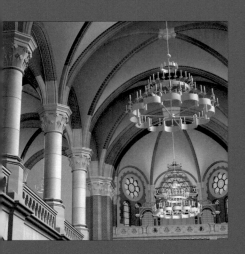

Munich

Munich

Herzog-Max-Strasse/corner Maxburgstrasse,
1887 – June 7, 1938

Munich's main synagogue, on Herzog-Max-Strasse at the corner of Maxburgstrasse, was erected between 1884 and 1887 by the architect Albert Schmidt. Schmidt, who was also the architect of the St. Lukas church, the Deutsche Bank and the Löwenbräukeller, designed a basilica-type three-aisled hall building. The center aisle (nave) of the synagogue, with a width of 11.30 meters and a height of 18 meters, had imposing dimensions. The synagogue's exterior was clearly defined by several towers that completed the composition on the west and east sides. Various materials such as brick, sandstone and roughcast served as decoration for the building, so no other ornamentation was necessary. Seating 1,000 men and 800 women, the Munich synagogue was one of the most important Jewish houses of worship in the lands where German was spoken. Until its destruction, the synagogue was well accepted by the public and was considered an asset to the cityscape.

On June 7, 1938, five months before the Reichspogromnacht, an order – which came personally from Hitler – was given to tear down the synagogue due to "traffic technicalities." Just a day later, demolition began and the Nazi press cynically commented: "an eyesore vanishes."

The Jewish community, which was for the most part liberally oriented and had around 11,000 members in 1919, no longer existed by 1945. Due to the recent wave of immigrants from the former states of the Soviet Union, the congregation has again grown to more than 7,000 members in recent years.

Today on the vacant lot where the synagogue once stood, only a memorial stone bears witness to the building and the fateful past.

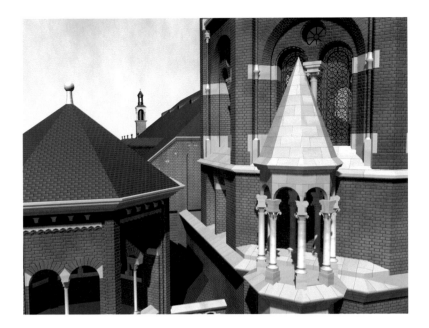

top: Details of the front towers
bottom: View of the entire building

right page: Front view

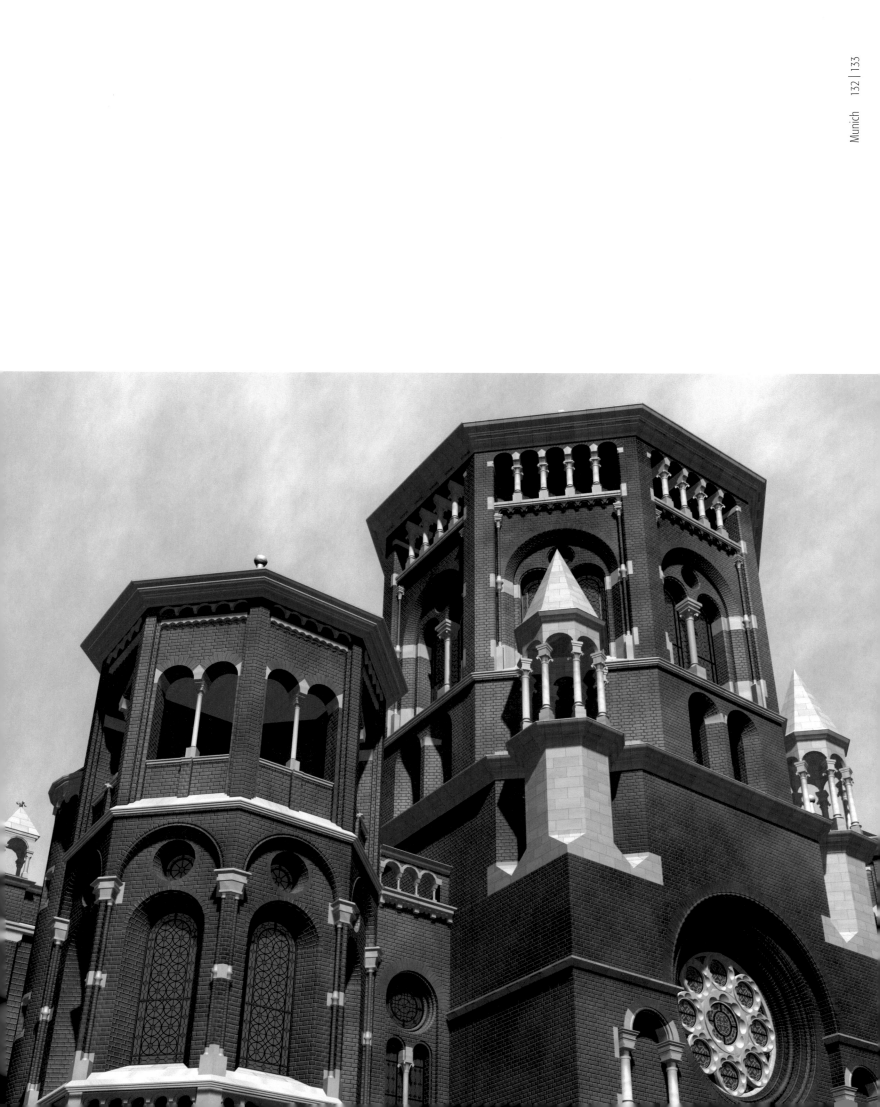

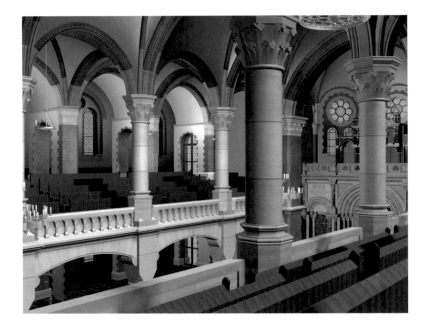

left page top: View from the south women´s gallery
middle: View from the aisle
bottom: View of the Aron ha-Kodesh

left: Interior view of the entrance
right: View from the west gallery to the Aron ha-Kodesh

Illustration pp. 136/137: Interior view from the west

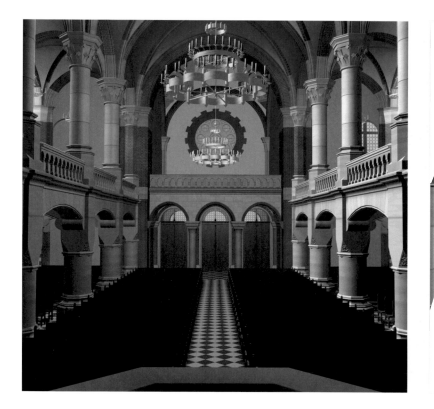

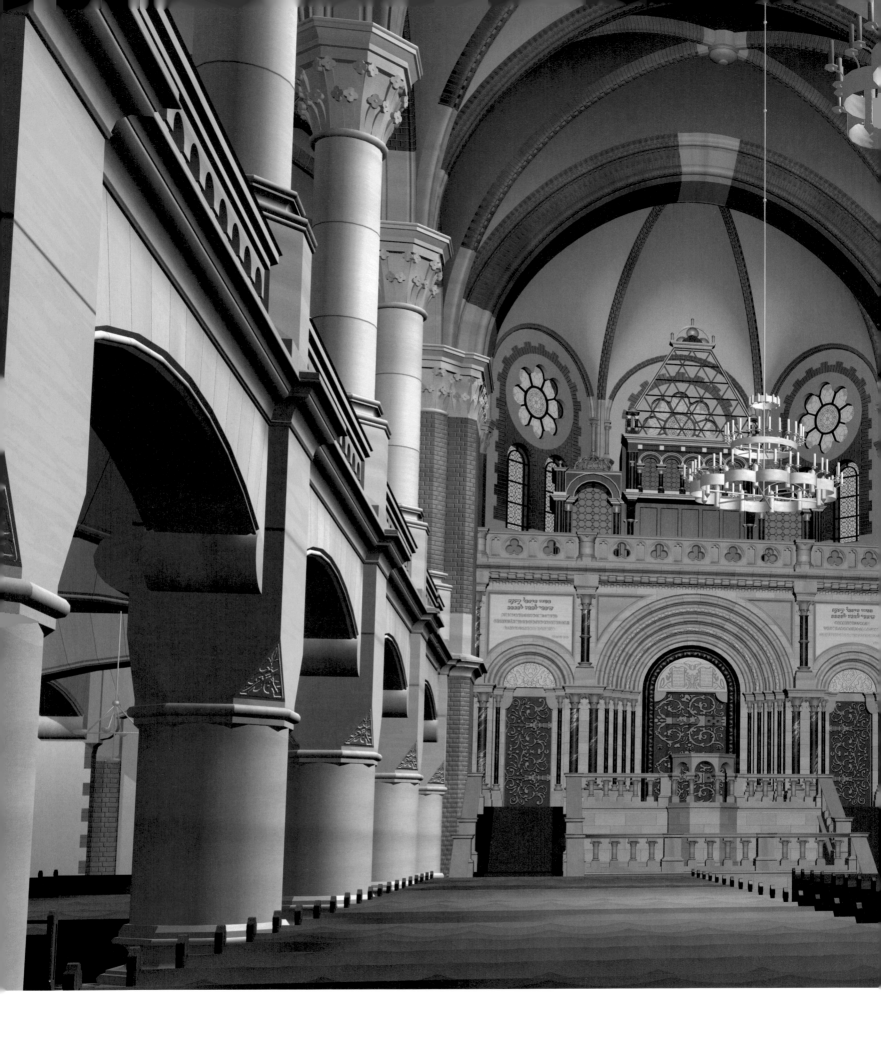

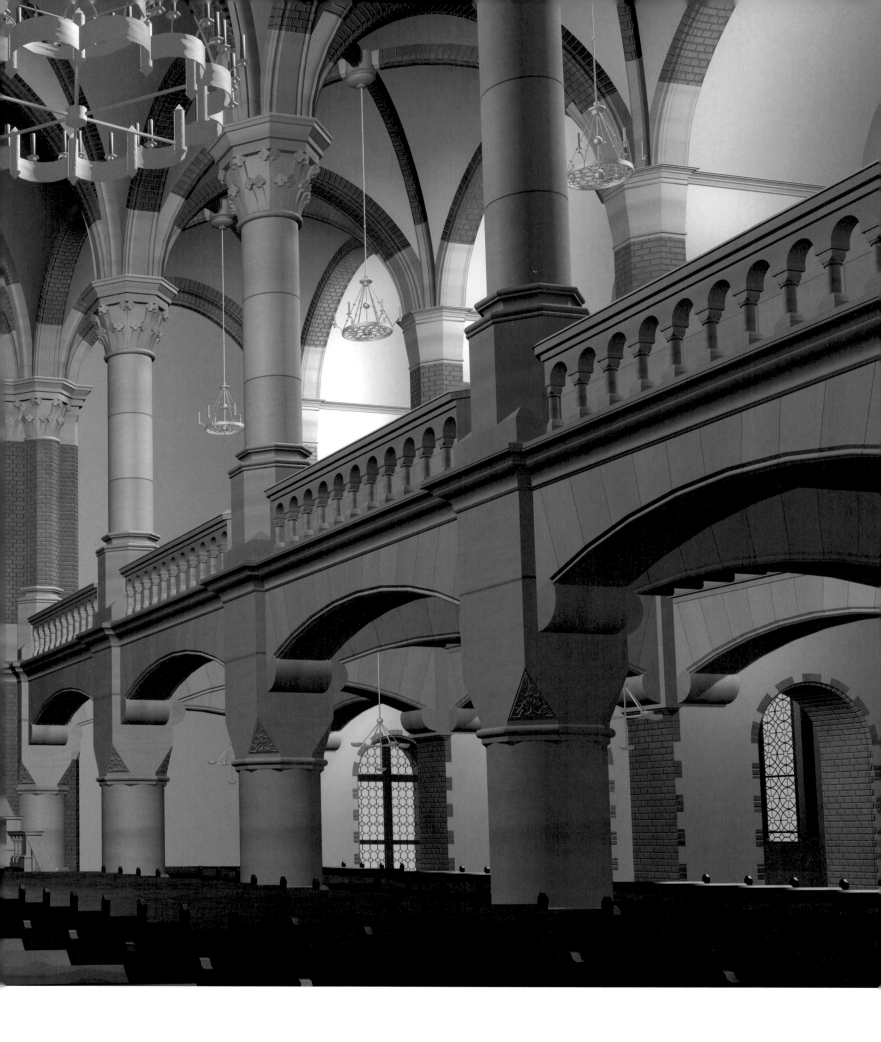

Plauen

Senefelder Strasse / corner Engelstrasse,
1930 – November 10, 1938

Built in 1930, the synagogue designed by Fritz Landauer was destroyed only eight years later in the Reichspogromnacht. This synagogue in Plauen was one of the few examples of a community center with an integrated synagogue in the style of the Neue Sachlichkeit (New Objectivity, also: International style). The structure, which was the next to last large synagogue built before Hitler was appointed Reich Chancellor, was an affirmation of the belief of the architect and his client in modern architecture and testified as well to the self-confidence of this Jewish congregation. The new center was important not only to the 800 members living in Plauen, but also to other Jews living in the towns of the Vogtland region in Saxony. The building's design clearly deviated from the conventional concept of space that called for a strict division between religious and communal rooms. Such a division was expressed on the exterior of the Plauen synagogue only by the white plastered walls of the prayer hall, which rested on a base made of reddish-brown clinker bricks. The floor plan shows a rectangular space that took into account the liberal understanding of the equal status of prayer and sermon. The prayer hall itself gave the impression of being plain yet ceremonial. The spare quality of the interior heightened the effect of the sgraffito on the east wall; this ornamentation was done in restrained colors and depicted Judaic symbols.

About half of the Jewish population of Plauen, mostly young people, was able to flee from Nazi persecution. The majority of Jews who stayed behind were deported by 1942. Today there is no longer a Jewish community in Plauen.

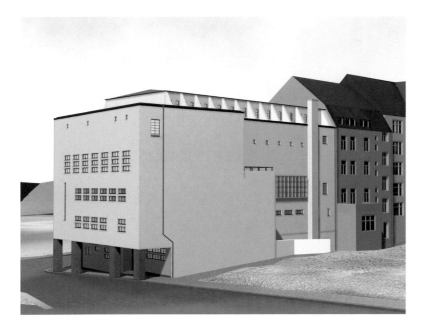

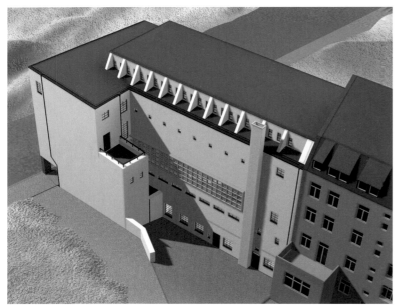

top: View of the south and the west façades
bottom: View from the top

right page: View of the north and the west façades

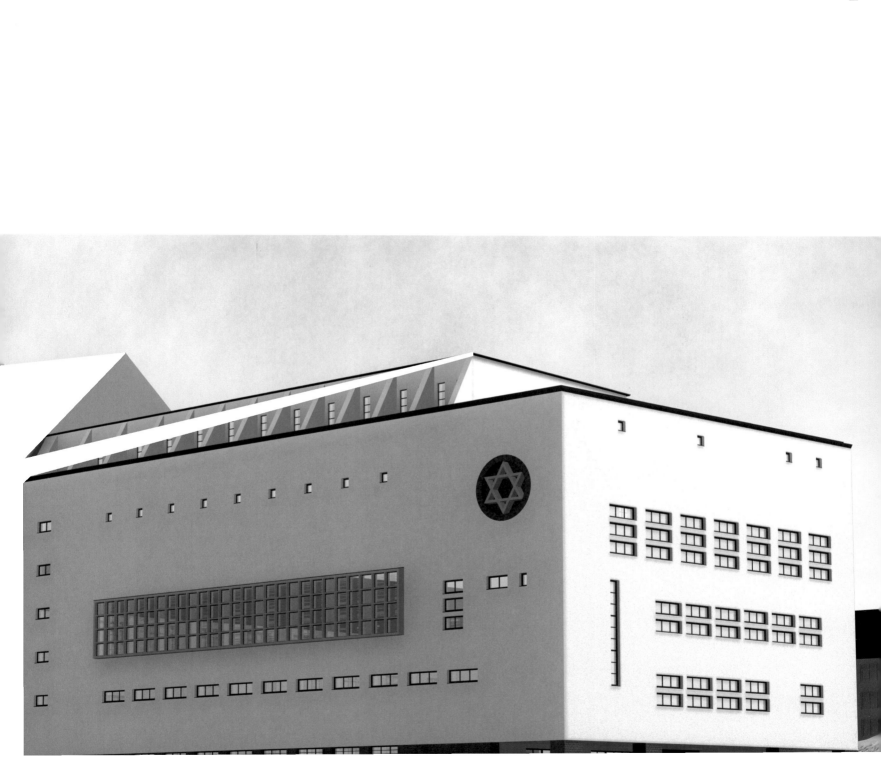

from top to bottom:
View from the west gallery of the Aron ha-Kodesh and the gallery with the organ
View of the Aron ha-Kodesh
Details of the chandelier
Gallery with organ

right page top: Under the south women's gallery
bottom: View of the south women's gallery to the west gallery

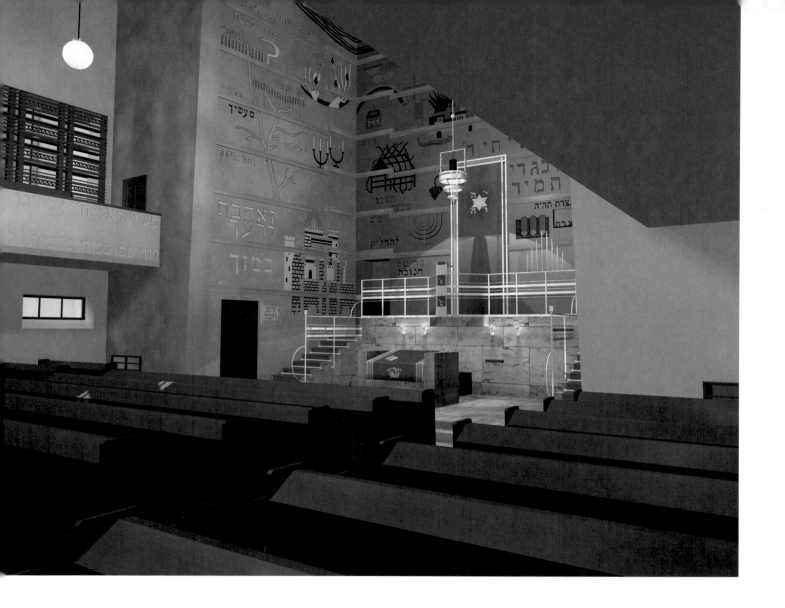

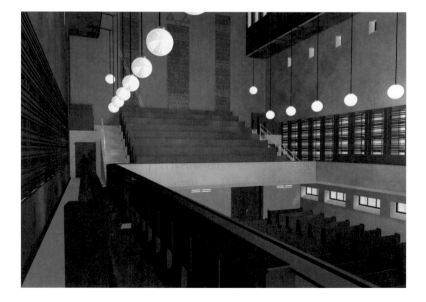

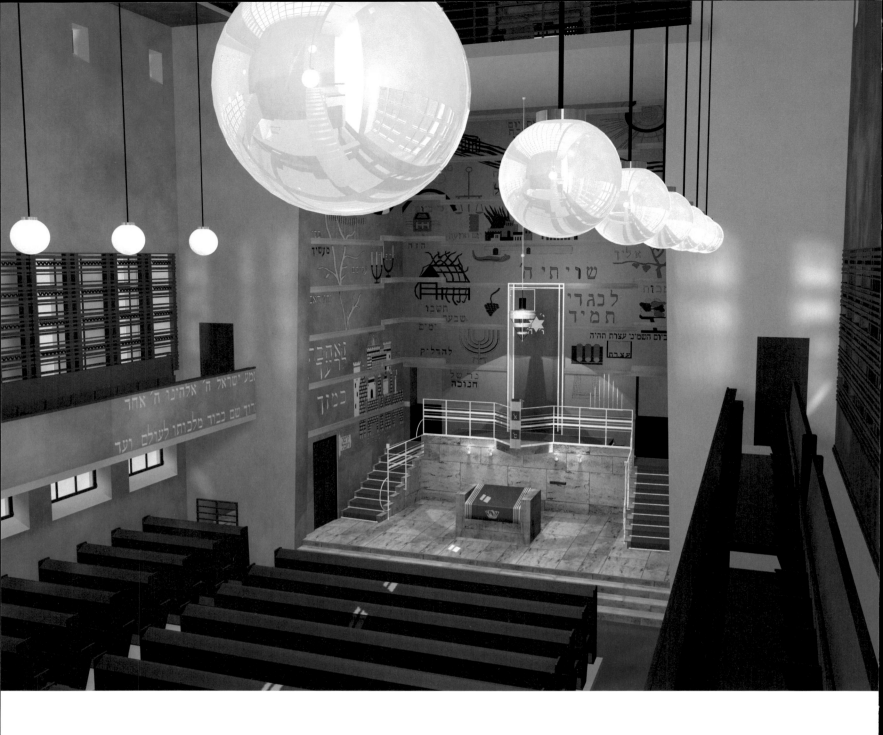

View from the women´s gallery of the Aron ha-Kodesh

Stephan Wirtz
Chronology

1933

January 30, 1933 – Hitler is appointed Reich Chancellor.
President Hindenburg appoints Hitler Reich Chancellor. The persecution of political enemies, Social Democrats and Communists in particular, begins and becomes even more brutal after the burning of the Reichstag building. On March 5, 1933 the parties behind Hitler, the NSDAP (Nationalsozialistische Deutsche Arbeiterpartei, National Socialist German Worker's Party) and the DNVP (Deutschnationale Volkspartei, German National People's Party), are elected by an absolute majority.

April 1, 1933 – Boycott and Professional Bans against Jews
Attacks on Jews and their businesses increase after the elections. On April 1, 1933, the local actions of the SA (Sturmabteilung, Stormtroopers) and NSDAP culminate in a boycott of Jewish businesses across the German Reich. These attacks are followed by an administrative measure, the "Law to Restore the Civil Service with Life-Long Security," which also sanctions the dismissal of "non-Aryan" civil servants with the exception of former frontline soldiers. In the following weeks, similar decrees affecting doctors, pharmacists, lawyers and other independent professions are imposed. As Jews are being banned from numerous professions, "Aryan Amendments" are adopted by many organizations and clubs sanctioning even personal discrimination against the Jews.

May 10, 1933 – Book Burning
Throughout Germany, books by Jews and other politically unpopular authors are burned in the public.

Summer 1933
The citizenship of Jews, who were naturalized during the Weimar Republic, is revoked. Gentiles are advised to divorce their Jewish wives, asserting that such women are merely hiding their Jewish heritage. Jews are prohibited from or severely restricted in their use of public baths throughout most of the German Reich.

1935

May – August 1935
The press engages in increased rabble-rousing and boycott propaganda against Jews. Many cities see new violent attacks and pogrom-like excesses against Jews, particularly in Berlin.

September 15, 1935 – Nuremberg Laws
During the NSDAP convention, the Reichstag passes the so-called Nuremberg Laws. The "Reichsbürgergesetz" (Reich Citizenship Law) makes a distinction between "Aryan members of the Reich" and common "citizens". This is the law which will legitimate further ordinances against Jews, stripping them of more and more civil liberties and protection. The "Gesetz zum Schutz des deutschen Blutes und der deutschen Ehre" (Law for the Protection of German Blood and German Honor) prohibits marriage and pre-marital sex between Gentiles and Jews. In addition, Jews are prohibited to employ German household help and are no longer allowed to fly the flag of the German Reich.

November 14, 1935
Citing the "Reichsbürgergesetz", the Jewish right to vote is revoked.

1938

March 13, 1938
The "Wehrmacht" (Armed Forces of the German Reich) marches into Austria. The atmosphere in Vienna is pregnant with anti-Semitic street terror. Jews are beaten, robbed and humiliated publicly, often with strong participation of the Austrian population. Many Jews flee to neighboring countries.

Spring/Summer 1938
Beginning at the end of 1937, the ministerial administration institutes numerous laws that ultimately seek to purge all Jews from economic life. Jews are required to register any wealth beyond 5,000 Reichsmark. By June they are required to have registered their companies. Starting in July, additional professional bans for brokers and salesmen are ordered, and the licenses of any remaining Jewish doctors and lawyers are finally revoked. Also in July, Jews are issued special passes and ordered to adopt the additional first name of Sarah or Israel, an ordinance intended to humiliate them while making them easily identifiable as Jews.

August 20, 1938
Under the auspices of Adolf Eichmann, the "Zentralstelle für jüdische Auswanderung" (Central Office for Jewish Emigration) is established in Vienna, with the objective of increasing governmental pressure on the Jews to emigrate, as well as facilitating and centralizing all aspects of the emigration.

October 28, 1938
17,000 Jews of Polish decent, most of whom had lived in Germany for decades, are deported. As they are not accepted as Polish citizens by the Polish authorities, they are forced to camp for days under inhuman conditions in a "no man's land" between Germany and Poland. Among those deported are the parents of Herschel Grynszpan.

November 7, 1938
In response to the treatment of the Jews in Germany and specifically his parents, Herschel Grynszpan shoots Ernst vom Rath, a German diplomat in Paris, critically injuring him. Vom Rath dies two days later.

1939

January 24, 1939

To further force the emigration of Jews, the "Reichs-zentrale für jüdische Auswanderung" (Reich Central Office for Jewish Emigration), is founded under the direction of Heydrich, the head of the Security Police and the Security Service (SD, Sicherheitsdienst) of the SS. This move gives the SS a central position in the planning and implementation of anti-Semitic measures.

September 1, 1939

Germany invades Poland and World War II begins. The Wehrmacht is followed by commandos of the SS, who kill several thousand Jews, potential political enemies and Polish intellectuals. An 8 p.m. curfew is imposed on Jews throughout Germany.

October 12, 1939

The first deportation of Jews from Austria to Poland. Despite the original plans of the SD, deportations are halted after only one more train, as the Wehrmacht needs the trains for the preparation of the Western war campaign, and as the Polish administration is not prepared for the arrival of such a large number of Jews.

November 23, 1939

Jews in the newly formed "Generalgouvernement Poland" are forced to wear the Yellow Star.

1940

February 8, 1940

The first Jewish ghetto is ordered to be built in a large city, Lódz. Over the next few months, all Jews in Poland are forced, little by little, to organize themselves in ghettos.

February 12 – 13, 1940

The first deportation of Jews from Germany (Stettin) to Poland. After protests from Governor-General Frank of Poland, Göring orders a halt to the transports.

May 10, 1940

Germany attacks the Netherlands, Belgium, Luxembourg and France.

July 19, 1940

Jews are required to surrender all telephones.

October 16, 1940

The Warsaw ghetto is built. Approximately 450,000 Jews are squeezed into little more than 3.5 square kilometers. Over 80,000 of them would die by September 1942 from starvation and illness.

November 9–10, 1938

The National Socialists use vom Rath's death as pretext for their pogrom, the Reichspogromnacht (so-called Reichskristallnacht or "Night of Broken Glass"), on the night of November 9. In the space of dusk to dawn approximately 7,500 stores are damaged and plundered, more than 1,400 synagogues and houses of prayer were destroyed or desecrated, and at least 91 Jews are killed. 20,000 to 30,000 Jewish men are arrested by the SS (Schutzstaffel, paramilitary commando of the National Socialists) and sent to concentration camps in Dachau, Sachsenhausen and Buchenwald, where they are degraded and tortured. Several hundred of them would not survive.

November 12, 1938

Complete expropriation of the Jewish population is agreed upon during a national conference chaired by Hermann Göring. By the end of the year, the remaining Jewish business owners have to either close their businesses altogether or sell them far below market value. In addition, Jews are forced to pay one billion Reichsmark for what was termed "restitution." The damage inflicted during the "Reichskristallnacht" is to be repaired at the cost of the Jewish communities. Any insurance settlements are confiscated by the state. In the wake of the November pogrom, Jews are prohibited from visiting museums, theaters and other cultural institutions, their driver licenses are revoked, and the last Jewish children are expelled from "German schools." The severe restrictions placed on Jewish civil liberties and their complete isolation from "Aryans" has been accomplished.

1941

February 1941

The SD begins the deportation of 250,000 Jews from the area around the Warthe River, and 60,000 Jews from Vienna to Poland. Due to transport problems and local resistance, the SD has to prematurely halt the "relocations" a second time.

June 22, 1941

During the attack on the Soviet Union, commandos of the SD, aided by the SS and the Wehrmacht, begin mass executions and pogroms. Within five months, they kill half a million Jews. By the time the Germans would surrender in Stalingrad, they will have killed 1.25 million Jews.

September 1, 1941

As per police ordinance by September 15, all Jews age six and up are required to wear the Star of David.

September 3, 1941

The first human beings are killed with the insecticide Cyclone B in Auschwitz. The victims of this "experiment" are 600 Soviet prisoners of war along with 250 infirm inmates.

October 24, 1941

The deportation to the East of 50,000 Jews from the "Altreich" (Old Reich), as well as from Austria and the Protectorate of Bohemia and Moravia is ordered. This starts the systematic deportation of Jews from Germany. Yet at the time there are still uncertainties as to what to do with German Jews: at some destinations the new arrivals are shot immediately, while at others they are squeezed together into ghettos first.

October 1941

Preparations to erect the first extermination camp in Belzec begin. Actual construction begins in November. The mass gassing by carbon-monoxide begins in March. About 600,000 people, mostly Jews, were killed in Belzec.

End of December 1941

Upon the initiative of local SS officers, Jews are murdered in mobile gas wagons in camp Chelmno.

1942

January 20, 1942
At the Wannsee Conference, Heydrich, the head of the Reichssicherheitshauptamt (RSHA, Reich Security Main Office) and the Sicherheitsdienst (SD), briefs state department secretaries there present about the current status of and further plans for the extermination of the Jews. The major objective of this conference is to coordinate the various departments involved in what was termed the so-called "Endlösung der Judenfrage" – Final Solution of the Jewish Question.

February – May 1942
Even though the deportation of Jews from the Reich had already begun and their eventual destruction had been agreed upon, a series of humiliating ordinances is nevertheless passed. Jews are no longer allowed to keep pets, have newspapers delivered or use public transportation.

July 22 – September 12, 1942
Mass deportations of approximately 300,000 Jews from the Warsaw ghetto. About 265,000 of them are brought to Treblinka, where almost all of them are immediately murdered.

1943

February 27, 1943
In Berlin, approximately 11,000 Jews, mostly workers in arms production, are arrested for deportation. Among them are 1,500 Jews living in mixed marriages. Several hundred spouses, children and fiancées, almost exclusively women, protest the arrest and eventually succeed. Their spouses are released.

April 19, 1943
German police forces begin deporting the remaining 60,000 Jews of the Warsaw ghetto. They are met with strong resistance from the United Jewish Combat Organization and from a large percentage of the unorganized ghetto population. Despite substantial military intervention, the SS and the Wehrmacht are unable to quell the revolt until May 16. Yet the resistance in the Warsaw ghetto is not an isolated incident. Underground organizations spring up in approximately 100 ghettos intending to organize revolts, or to escape the ghetto in order to fight a partisan's war.

May 24, 1943
Approximately 10,000 people, mostly Jews, demonstrate against the imminent deportations in Sofia. The resistance of Bulgarian Jews is supported by the Orthodox Church and the Communist Party, and finds a tide of support among the general population as well. This prevents the deportations, and the Bulgarian Jews are saved from extermination.

October 1–2, 1943
German police begin the deportation of Jews from Denmark. In an effort lasting several weeks, the Danish resistance smuggles about 7,200 Jews to safety to Sweden.

October 14, 1943
Revolt and mass escape from the extermination camp Sobibor.

1944

May 15 – July 9, 1944
437,000 Hungarian Jews are deported to Auschwitz. Almost all of them are murdered immediately after their arrival.

October 6 – 7, 1944
Prisoners assigned to the Sonderkommando stage an uprising at Auschwitz and destroy one of the gas chambers.

1945

January 17, 1945
The SS clears Auschwitz. The death march of 66,000 prisoners to Wodzislaw begins, where they are to be distributed throughout several camps. 15,000 die on the way.

January 27, 1945
The Red Army liberates 7,650 prisoners in Auschwitz.

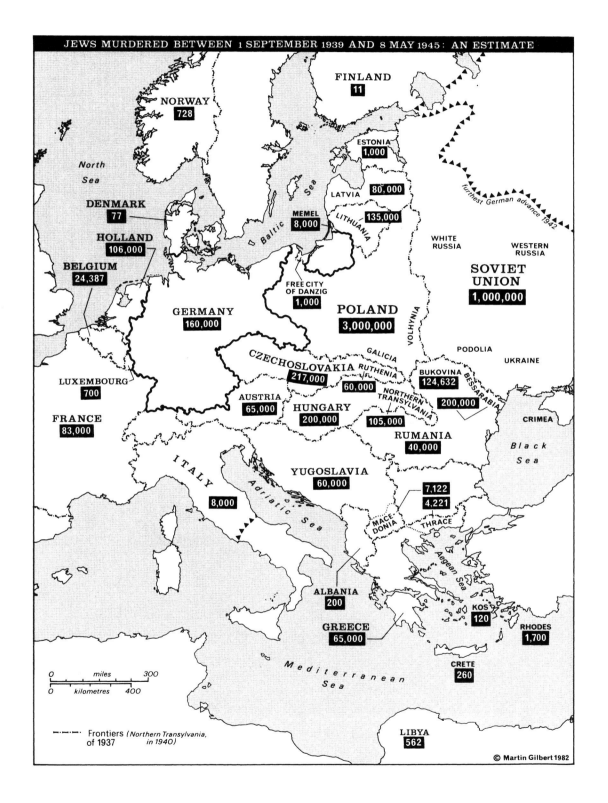

JEWS MURDERED BETWEEN 1 SEPTEMBER 1939 AND 8 MAY 1945: AN ESTIMATE

FINLAND
11

NORWAY
728

North
Sea

ESTONIA
1,000

Baltic Sea

LATVIA
80,000

DENMARK
77

MEMEL
8,000

LITHUANIA
135,000

furthest German advance 1942

WHITE
RUSSIA

WESTERN
RUSSIA

HOLLAND
106,000

FREE CITY
OF DANZIG
1,000

GERMANY
160,000

POLAND
3,000,000

SOVIET
UNION
1,000,000

BELGIUM
24,387

VOLHYNIA

PODOLIA

UKRAINE

GALICIA

CZECHOSLOVAKIA
217,000

RUTHENIA

BUKOVINA
124,632

BESSARABIA

LUXEMBOURG
700

60,000

NORTHERN
TRANSYLVANIA

200,000

AUSTRIA
65,000

HUNGARY
200,000

105,000

CRIMEA

FRANCE
83,000

RUMANIA
40,000

Black
Sea

ITALY

YUGOSLAVIA
60,000

Adriatic Sea

7,122
4,221

MACE-
DONIA

THRACE

8,000

Aegean Sea

ALBANIA
200

KOS
120

GREECE
65,000

RHODES
1,700

Mediterranean
Sea

CRETE
260

0 miles 300
0 kilometres 400

LIBYA
562

Frontiers (Northern Transylvania, of 1937 in 1940)

© Martin Gilbert 1982

Agnieszka Lulinska
Glossary

Almemor (from Arabic, pulpit): see Bimah

Ark of the Covenant: see Aron ha-Kodesh

Aron ha-Kodesh
(Holy Ark, Holy of Holies, Thora shrine)
The Hebrew term goes back to the biblical Ark of the Covenant, which held the stone tablets inscribed with the Ten Commandments received by Moses. The Ark of the Covenant has been lost since the destruction of the Temple in 586 BCE. Today the term Aron ha-Kodesh refers to the chest holding the Torah scrolls in the synagogue. Originally the Aron ha-Kodesh was standing by itself at the wall pointing towards Jerusalem, until a special apse was created.

Ashkenazic, Ashkenazim
A term from the Middle Ages, referring to the Jews living in the area which became today's Germany and France. Following the crusades, the term also included all Jews and their descendants who fled to central and eastern Europe.

Bar Mitzvah
On the Sabbath following his 13th birthday, a boy ceremoniously becomes "a son of command-ment". For the very first time he is called upon for his Aliyah, the reading of a portion of the Torah. From this moment on, he is considered to be a reli-giously mature member of the prayer circle of his community.

Basilica
A multi-aisled hall with a raised middle-aisle and low side aisles popular in Roman architecture, some-times including emporiums and apses. Originally the basilica was of a secular nature, serving as market hall, site of jurisprudence and congregation. The earliest synagogue reminiscent of a basilica was built in Alexandria in the 2nd or 3rd century BCE.

Bet ha-Knesset
The Hebrew term means "house of congregation", and is identical to the Greek term "synagogue", meaning "congregation". The term refers to the site for prayer, learning and congregation central to any Jewish Community.

Bimah (or Almemor, from Arabic: pulpit)
Hebrew term for the podium where the Torah is read. In the orthodox Ashkenazic synagogue the bimah is in the center of the room, while in liberal reform synagogues it is on the end of the prayer hall in front of the Torah shrine. In synagogues fol-lowing the Sephardic rituals the bimah is posi-tioned on the eastern wall, opposite to the Torah shrine.

Cantor
Originally the supervisor of a congregation during prayer, today it is the person leading the congre-gation in prayer and singing.

Chanukah
The festival of lights celebrated at the beginning of the winter solstice. The celebration commemo-rates the victory of Judah Maccabee over the Syrian King Antiochus IV in the year 165 BCE. It also commemorates the ceremony initiating the Second Temple of Jerusalem. On Chanukah, a cande-labra that holds nine candles (chanukia), one for each night and a ninth candle (shamosh) to light them, is used. The eight candles are lit on eight con-secutive nights with the shamosh.

Diaspora
This Greek term for "dispersion" refers to all Jewish communities outside of the and of Israel since the Babylonian exile in the 6th century BCE.

Emporium
A stand or gallery on columns which was the women's place during the service. In the 16th century the women's emporiums replaced the sep-arate women's chambers of earlier synagogues.

Holy Ark, Holy of Holies: see Aron ha-Kodesh

Kaddish
A term derived from the Aramaic "holy": A prayer in praise of God's holiness from the 1st or 2nd century. It expresses hope for an end to the Diaspora. Today the Kaddish is said by the sons during mourning rituals following their parents' death.

Kashrut, Kosher
Originally the rabbinical laws for cleanliness rooted in biblical rules. Today they mainly refer to the preservation and preparation of food. The basic rules require that meat and milk products do not come in physical contact with each other, and are therefore prepared in and eaten from separate dishes.

Kiddush
This prayer, spoken by the man of the house over a cup of wine, initiates the Shabbat on Friday evenings.

Menorah
A seven-armed candelabra. The Temple of Solomon (957 to 586 BCE) supposedly housed ten meno-rahs. The Second Temple (515 BCE to 70 CE) housed only a single menorah, which, when Jerusalem was conquered by the Roman Emperor Titus in 70 CE, was stolen and, along with other furnishings of the Temple, brought to Rome.

Mikvah
The ritual bath for the monthly cleansing of women, as well as for ritual cleansings of men for spiritual purification. It was usually in or at least close to the synagogue. During the bath only "pure" spring or rain water could be used.

Minyan
A group comprised of ten men over the age of 13, therefore considered to be religiously mature, who recite certain prayers during service.

Orthodox
Strict religious expression of Judaism. Orthodox Jews follow the traditional rules of both the written and oral law in all aspects of their daily life. The revelation at Mount Sinai is considered central to all teachings, and all other historical events are viewed as meaningless in comparison.

Pentateuch
The Greek term refers to the Five Books of Moses: Genesis, Exodus, Leviticus, Numbers and Deuteronomy.

Pesach
The Festival of Spring (Hebrew: Passover), commemorating the Exodus of the people of Israel from Egypt and the liberation from enslavement by the Pharaoh.

Purim
The Festival of Joy, commemorating the rescue of the Jews from extermination at the hand of the Grand Vizier Haman, chief minister to the King of Persia, in the 6th century BCE.

Rabbi
Originally a term for those well versed in Jewish scripture and religious teachings. Today a term for ordained Jewish clergy.

Reformed Judaism, Liberal Judaism
A reform movement in the wake of Jewish social emancipation. With all due respect for the traditional laws, the reformers deny the necessity of their binding application and implementation in all aspects of life, requiring an adaptation of the traditional laws to the conditions of modernity. The impetus for change mainly refers to a new regulation of the order of prayer, an introduction of the national language during service, and the introduction of choir and organ music.

Rosh Hashanah
The Jewish New Year (Hebrew lit.: head of the year). Yom Kippur follows after the ten days of repentance.

Shabbat, Sabbath
A holy day in honor of God, from Friday evening through Saturday evening. During this time all work must cease. The holy day is devoted to religious edification, commemorating the seventh day of creation, on which God rested.

Sephardic, Sefardim
This term is traditionally used for Jews and their descendants from the Iberian Peninsula. After they were expelled from Spain, Portugal and Southern France in 1492, the Sephardic Jews settled in Italy, the Ottoman Empire, the Netherlands and Northern Africa.

Shul
The term, originally derived from the Italian "scuola", refers to the house of worship, the synagogue. When translating the New Testament, Martin Luther used the term "Schule" for the synagogue, and thus introduced it to the German language.

Succot, Succah
The Feast of Booths (or Tabernacles), celebrated in autumn and commemorates the 40 years of wanderings of the people of Israel in the dessert. It is originally a harvest festival.

Synagogue: see Beth ha-Knesset

Talmud
Aside from the Torah, the Talmud is the most important basis of Jewish religious teachings. The Talmud consists of the Mishnah, which deals with jurisprudence and religious law, and the Gemara, which contains commentary on the Mishnah.

Torah
This Hebrew term for "education" refers to the Five Books of Moses (Pentateuch), which are considered the holiest foundation of the Jewish religion. Together with the prophetic and historical books, the Torah forms the written law, whereas the Talmud is considered to be the oral law. Every single Saturday a predetermined paragraph of the Torah is read at the synagogue.

Torah crown
The beautifully ornamented crown of the Torah scrolls, which is placed on the upper ends of the Torah sticks.

Torah hand
The Torah hand is considered a reading help for the Holy Scriptures, since the Torah cannot be touched by hand. The Torah hands, usually made of gold and silver, consist of an artfully ornamented shaft that is topped by a hand with pointing index finger at its end.

Torah scrolls
The handwritten Pentateuch on parchment. The Torah scrolls are rolled onto two sticks, bound together by a pennant, and wrapped in the Torah coat. The Torah scrolls are kept in the Aron ha-Kodesh within the synagogue. It is the most precious possession of any Jewish community.

Torah shrine: see Aron ha-Kodesh

Yom Kippur
The Day of Atonement, the holiest day of the Jewish year, ends the ten "days of repentance" which follow Rosh Hashanah, the New Year's Day service. It is said that during these ten days God decides upon the fate of every single human being: He inscribes their names in a book, distinguishing between those who were good and will live, and those who were evil and will die. The fate of those in between will be decided on Yom Kippur, the Day of Atonement.

Hebrew transcription follows the Jewish Glossary (www.somethingjewish.co.uk/judaism_guide/ jewish_glossary/index.htm#t)

Bibliography

Architecture and History of the Synagogue:

BRIAN DE BREFFNY, *The Synagogue*, Jerusalem, 1978

THEODOR A. BUSINK, *Der Tempel zu Jerusalem von Salomon bis Herodes: Eine archäologisch-historische Studie unter Berücksichtung des west-semitischen Tempelbaus*, 2 vols., Leiden, 1970/80

JOSEPH CARLEBACH, *Die Architektur der Synagoge*, in: *Ausgewählte Schriften*, ed. MIRIAM GILLIS-CARLEBACH, 2 vols., Hildesheim, 1982

MARYLIN JOYCE SEGAL CHIAT, *Handbook of Synagogue Architecture*, Brown Judaic Studies 29, Chico, 1982

DAVID DAVIDOVICZ, *Wandmalerei in alten Synagogen*, Hameln, 1969

SIMON DUBNOW, *Weltgeschichte des jüdischen Volks*, 10 vols., Berlin, 1925–29

AZRIEL EISENBERG, *The Synagogue Through the Ages*, New York, 1974

ISMAR ELBOGEN, *A Century of Jewish Life,* trans. Moses Hadas, Philadelphia, 1945

ISMAR ELBOGEN, *Jewish Liturgy: A Comprehensive History*, trans. Raymond P. Scheindlin, Philadelphia, 1993 (based on the original 1913 German and the 1972 Hebrew edition)

LOUIS FINKELSTEIN, *Origin of the Synagogue*, in: *Proceedings of the American Academy for Jewish Research 1*, 1928–30, p. 49–59

UMBERTO FORTIS, *Jews and Synagogues*, Venice, 1973

HEINRICH FRAUBERGER, *Über Bau und Aus-schmückung alter Synagogen*, Frankfurt/Main, 1901

HEINRICH FRAUBERGER, *Objects of Ancient Jewish Ritual Art and Illuminated Hebrew Script and Ornaments of Printed Books*, reprint of the 1903 and 1909 edition, Jerusalem, 1970

MICHAEL GRAETZ AND HANNELORE KÜNZL (eds.), *Vom Mittelalter in die Neuzeit: Jüdische Städtebilder Frankfurt*, Prag, Amsterdam, Heidelberg, 1999

ALFRED GROTTE (ed.), *Deutsche, böhmische und polnische Synagogentypen vom 11. bis Anfang des 19. Jahrhunderts*, Berlin, 1915

ERNST GUGGENHEIMER, *Aus der Geschichte des Synagogenbaues*, in: *Festschrift zur Einweihung der Synagoge in Stuttgart am 13. Mai 1952*, ed. Israelitische Kultusvereinigung Württemberg und Hohenzollern, Stuttgart, 1952

JOSEPH GUTMANN (ed.), *The Synagogue: Studies in Origins, Archaeology and Architecture*, New York, 1975

ARNO HERZIG, *Jüdische Geschichte von den Anfängen bis zur Gegenwart*, Munch, 1997

JULIUS HÖXTER, *Source book of Jewish History and Literature*, abridged ed., London, 1983

KURT HRUBY, *Die Synagoge. Geschichtliche Ent-wicklung einer Institution*, Zurich, 1971

ABRAHAM KANOF, *Jewish Ceremonial Art and Religious Observance*, New York, 1971

URI KAPLOUN (ed.), *The Synagogue*, Jerusalem, 1973

LUDWIG KLASEN, *Jüdische Tempel oder Synagogen*, in: *Grundrißvorbilder von Gebäuden für kirchliche Zwecke*, Leipzig, 1889

HEINRICH KOHL and CARL WATZINGER, *Antike Synagogen in Galiläa*, Leipzig, 1916, reprint Jerusalem, 1973

KAUFMAN KOHLER, *The Origins of the Synagogue and the Church*, New York, 1929

SAMUEL KRAUSS, *Synagogale Altertümer*, Berlin, 1922

RICHARD KRAUTHEIMER, *Mittelalterliche Synagogen*, Berlin, 1927

CAROL HERSELLE KRINSKY, *Synagogues of Europe: Architecture*, History, Meaning, New York, 1996

RENATE KRÜGER, *Die Kunst der Synagoge. Eine Ein-führung in die Probleme von Kunst und Kult des Judentums*, 2d ed., Leipzig, 1968

HANNELORE KÜNZL, *Islamische Stilelemente im Synagogenbau im 19. und frühen 20. Jh.*, Frankfurt/Main, 1984

Jüdische Kunst. Von der biblischen Zeit bis in die Gegenwart, Munich, 1992

HANS LAMM, *Synagogenbau gestern und heute*, in: *Baumeister 63*, 1966, p. 53–59

ISAAC LEVY, *The Synagogue. Its History and Function*, London, 1963

WILHELM MAURER, *Kirche und Synagoge. Motive und Formen der Auseinandersetzung der Kirche mit dem Judentum im Laufe der Geschichte*, Stuttgart, 1953

HAROLD ALAN MEEK, *The Synagogue*, London, 1995

ANDREAS NACHAMA AND GEREON SIEVERNICH (eds.), *Patterns of Jewish Life. Jewish Thoughts and Beliefs, Life and Work With the Cultures of the World*, exhibition catalogue, Martin Gropius Building, trans. Mitch Cohen, Berlin, 1992

ANNEGRET NIPPA AND PETER HERBSTREUTH, *Eine kleine Geschichte der Synagoge in dreizehn Städten*, Hamburg, 1999

MARIA AND KAZIMIERZ PIECHOTKA, *Wooden Synagogues*, Warsaw, 1959

MATTHEW REISZ, *Europe's Jewish Quarters*, London, 1991

LAURIE ROSENBERG, *The Synagogue*, London, 1997

MOSES ROSENMANN, *Der Ursprung der Synagoge und ihre allmähliche Entwicklung*, Berlin, 1907

B. CECIL ROTH, *Die Kunst der Juden*, 2 vols., Frankfurt/Main, 1963–64

JULIUS H. SCHOEPS (ed.), *Neues Lexikon des Juden-tums*, Gütersloh, 1998

HANS-PETER SCHWARZ (ed.) et al., *Die Architektur der Synagoge*, exhibition catalogue, Deutsches Architekturmuseum Frankfurt/Main, Stuttgart, 1988

CAESAR SELIGMANN, *Geschichte der jüdischen Reformbewegung von Mendelssohn bis zur Gegenwart*, Frankfurt/Main, 1922

OTTO STOBBE, *Synagoga. Jüdische Altertümer, Handschriften und Kultgeräte*, Frankfurt/Main, 1961

PAUL THIRY, RICHARD M. BENNET and HENRY L. KAMPHOEFNER, *Churches and Temples*, New York, 1953

ARNOLD JOSEPH TOYNBEE (ed.), *The Crucible of Christianity: Judaism, Hellenism and the Historical Background to the Christian Faith*, London, 1969

SIMON P. DE VRIES, *Jüdische Riten und Symbole*, 7th ed., Wiesbaden, 1995

MAX WARNATSCH, *Innenausstattung der Kirchen und Synagogen*, Berlin, 1911–1914

GEOFFREY WIGODER, *The Story of the Synagogue*, London, 1986

RACHEL WISCHNITZER-BERNSTEIN, *The Architecture of the European Synagogue*, Philadelphia, 1964

History and Architecture of the Synagogue in Germany

HANS GEORG ADLER, *Die Juden in Deutschland von der Aufklärung bis zum Nationalsozialismus*, Munich, 1960

KLAUS ARLT et al., *Zeugnisse jüdischer Kultur. Erinnerungsstätten in Mecklenburg-Vorpommern, Brandenburg, Berlin, Sachsen-Anhalt, Sachsen und Thüringen*, Berlin, 1992

DIETER BARTETZKO, *Eine verschollene Architektur. Über Synagogen in Deutschland*, Frankfurt/Main, 1988

WOLFGANG BENZ (ed.), *Die Juden in Deutschland 1933–1945. Leben unter nationalsozialistischer Herrschaft*, Munich, 1988

MICHAEL BROCKE (ed.), *Feuer an Dein Heiligtum gelegt: Zerstörte Synagogen 1938 Nordrhein-Westfalen*, Salomon Ludwig Steinheim-Institut für deutsch-jüdische Geschichte, Bochum, 1999

TERJE N. DAHLE (ed.), *Synagogen*. Bibliographie. IRB-Literaturdokumentation, Stuttgart, 2000

ADOLF DIAMANT, *Zerstörte Synagogen vom November 1938. Eine Bestandsaufnahme*, Frankfurt/Main, 1978

HANS-JÜRGEN DÖSCHER, *Reichskristallnacht. Die Novemberpogrome 1938 im Spiegel ausgewählter Quellen*, Bonn, 1988

KLAUS DROBISCH, RUDI GOGUEL and WERNER MÜLLER, *Juden unterm Hakenkreuz, Verfolgung und Ausrottung der deutschen Juden 1933 bis 1945*, Berlin, 1973

ERNST L. EHRLICH, *Geschichte der Juden in Deutschland*, Düsseldorf, 1957

ISMAR ELBOGEN and ELEONORE STERLING, *Die Geschichte der Juden in Deutschland*, Berlin, 1935, reprint Frankfurt/Main, 1988

HELMUT ESCHWEGE (ed.), *Kennzeichen J. Bilder, Dokumente, Berichte zur Geschichte der Verbrechen des Hitlerfaschismus an den deutschen Juden*, Berlin, 1966

HELMUT ESCHWEGE (ed.), *Die Synagoge in der deutschen Geschichte: eine Dokumentation*, Wiesbaden, 1988

ANSELM FAUST, *Die "Kristallnacht" im Rheinland. Dokumente zum Judenpogrom im November 1938*, 3rd ed., Düsseldorf, 1988

PETER FREIMARK and WOLFGANG KOPITZSCH, *Der 9./10. November 1938 in Deutschland. Dokumentation zur "Kristallnacht"*, 5th rev. ed., Hamburg, 1988

NACHUM T. GIDAL, *Die Juden in Deutschland von der Römerzeit bis zur Weimarer Republik*, illustrated, Gütersloh, 1988

HEINZ MOSCHE GRAUPE, *The Rise of Modern Judaism: An Intellectual History of German Jewry 1650–1945*, trans. John Robinson, Huntington, 1979

ALFRED GROTTE (ed.), *Deutsche, böhmische und polnische Synagogentypen vom 11. bis Anfang des 19. Jahrhunderts*, Berlin, 1915

ALFRED GROTTE (ed.), *Kultbau der Vergangenheit. Vom Einfluß der deutschen Umwelt und Kunst auf den Synagogenbau*, in: *Central-Vereinzeitung*, 3 July 1931

HAROLD HAMMER-SCHENK, *Synagogen in Deutschland: Geschichte einer Baugattung im 19. und 20. Jahrhundert*, in: *Hamburger Beiträge zur Geschichte der deutschen Juden 8*, Hamburg, 1981

HAROLD HAMMER-SCHENK, *Untersuchungen zum Synagogenbau in Deutschland von der ersten Emanzipation bis zur gesetzlichen Gleichberechtigung der Juden (1800–1871)*, Diss., Tübingen, 1974

ARNO HERZIG, INA LORENZ, SHLOMO NA'AMAN (eds.), *Verdrängung und Vernichtung der Juden unter dem Nationalsozialismus*, in: *Hamburger Beiträge zur Geschichte der deutschen Juden 19*, Hamburg, 1992

WALTHER HOFER (ed.), *Antisemitismus im Dritten Reich. Dokumente 1933–1945*, Frankfurt/Main, Hamburg, 1957

THOMAS HOFMANN AND HANNO LOEWY (eds.), *Pogromnacht und Holocaust. Frankfurt, Weimar, Buchenwald. Die schwierige Erinnerung an die Stationen der Vernichtung*, Weimar, Cologne, Vienna, 1994

WILLI JASPER AND JULIUS H. SCHOEPS (eds.), *Deutsch-jüdische Passagen: europäische Stadtlandschaften von Berlin bis Prag*, Hamburg, 1996

WILLI JASPER AND JULIUS H. SCHOEPS (eds.), *Die Juden in Deutschland*, in: *Freiburger Rundbrief*, vol. 1963/64, no. 57/60, Freiburg, 1964

WANDA KAMPMANN, *Deutsche und Juden*, Heidelberg, 1963

KLEMENS KLEMMER, *Jüdische Baumeister in Deutschland. Architektur vor der Shoah*, Stuttgart, 1998

LIONEL KOCHAN, *Pogrom: 10 November 1938*, London, 1957

MANFRED KOOB, *Jüdische Sakralbauten: 3D CAD Visualisierung des Zerstörten; student works of the Department CAD in Architecture*, exhibition "Fragmente und Rekonstruktion", Museum Judengasse, Darmstadt, 1996

HANNELORE KÜNZL, *Synagogen*, in: *Kunst des 19. Jahrhunderts im Rheinland*, eds. EDUARD TRIER and WILLY WEYRES, vol. 1 Architektur I: Kultusbauten, Düsseldorf, 1980, p. 339–346

FRITZ LANDAUER, *Jüdischer Kultbau von heute*, in: *Central-Vereinzeitung*, 3 July 1931

MINISTERIUM FÜR ARBEIT, SOZIALES UND STADTENTWICKLUNG, KULTUR UND SPORT DES LANDES NORDRHEIN-WESTFALEN (ed.), *Zeitzeugen. Begegnungen mit jüdischem Leben in Nordrhein-Westfalen*, Düsseldorf, 1998

ELISABETH MOSES, *Jüdische Kult- und Kunstdenkmäler in den Rheinlanden*, in: *Zur Geschichte und Kultur der Juden im Rheinland*, ed. FALK WIESEMANN, Düsseldorf, 1985, p. 99–200

DIETER OBST, *"Reichskristallnacht". Ursachen und Verlauf des antisemitischen Pogroms vom November 1938*, Frankfurt/Main, 1991

MAX OPPENHEIMER, HORST STUCKMANN and RUDI SCHNEIDER, *Als die Synagogen brannten. Antisemitismus und Rassismus gestern und heute*, 3rd ed., Cologne, 1988

WALTER H. PEHLE (ed.), *November 1938: From Reichskristallnacht to Genocide*, trans. William Templer, Oxford, 1990

ELFI PRACHT-JÖRNS, *Jüdisches Kulturerbe in Nordrhein-Westfahlen*, vol. 1, Regierungsbezirk Köln, Cologne, 1997

ELFI PRACHT-JÖRNS, *Jüdisches Kulturerbe in Nordrhein-Westfahlen*, vol. 3, Regierungsbezirk Detmold, Cologne, 1998

HELEN ROSENAU, *German Synagogues in the Early Period of Emancipation*, in: *Leo Baeck Institute Year Book VIII*, 1963, p. 214–225

Synagogues in 19th century Germany, exhibition catalogue, Beth Hatefutsoth, The Nahum Goldman Museum of the Jewish Diaspora, Tel Aviv, 1982

RITA THALMANN and EMMANUEL FEINERMANN, CRYSTAL NIGHT: 9–10 NOVEMBER 1938, trans. Gilles Cremonesi, London, 1974

JÖRG WALLENBERG (ed.), *Niemand war dabei und keiner hat's gewußt. Die deutsche Öffentlichkeit und die Judenverfolgung 1933–1945*, Munich, 1989

SYLVIA ZACHARIAS, *Synagogengemeinden 1933. Ein Wegweiser zu ihren Spuren in der Bundesrepublik Deutschland*, ed. Verein zur Pflege des Jüdischen Kulturerbes in Deutschland, vol. 1, Berlin, 1988

FRANZ-JOSEF ZIWES (ed.), *Badische Synagogen aus der Zeit von Friedrich I. in: zeitgenössischen Photographien*, Karlsruhe, 1997

Berlin

VERONIKA BENDT AND ROLF BOTHE (eds.),
*Synagogen in Berlin. Zur Geschichte einer zerstörten
Architektur*, exhibition catalogue, 2 vols., Berlin
Museum, Berlin, 1983

HANS-GERD SELLENTHIN, *Geschichte der Juden in
Berlin und des Gebäudes Fasanenstraße 79/80*,
Festschrift anlässlich der Einweihung des jüdischen
Gemeindehauses, Berlin, 1959

MORITZ STERN, *Beiträge zur Geschichte der
jüdischen Gemeinde zu Berlin*, issue 1–6,
Berlin, 1926 and 1934

Cologne

ZVI ASARI (ed.), *Die Juden in Köln von den ältesten
Zeiten bis zur Gegenwart*, Cologne, 1959, p. 193, 353

CARL BRISCH, *Geschichte der Juden in Cöln und
Umgebung*, vol. 1 and 2, Cologne, Mühlheim, 1879
and 1882

OTTO DOPPELFELD, *"Residenzen Gottes".
Die ältesten Synagoge von Köln*, ed. Kölnische
Gesellschaft für christlich-jüdische Zusammen-
arbeit, Cologne, 1959

LEO JARDEN, *Jüdische Kult- und Kunstdenkmäler.
Aus der Geschichte der Juden im Rheinland*, in:
*Rheinischer Verein für Denkmalpflege und Heimat-
schutz*, issue 1, 1931

JÜDISCHES SCHICKSAL IN KÖLN 1918–1945,
exhibition catalogue, Historisches Archiv der Stadt
Köln/NS-Dokumentationszentrum, Cologne, 1988

HANNELORE KÜNZL, *Synagogenbauten des
19. Jahrhunderts in Köln*, in: *Köln und das rheini-
sche Judentum*. Festschrift Germania Judaica 1959–
1984, Cologne 1984, p. 226–234

KONRAD SCHILLING (ed.), *Monumenta Judaica.
2000 Jahre Geschichte und Kultur der Juden am
Rhein*, Kölnisches Stadtmuseum, 2 vols.,
Cologne 1963–64

*Vor 100 Jahren: Einweihung der Synagoge in der
Glockengasse*, in: KONRAD SCHILLING, *Ausgewähl-
te Quellen zur Kölner Stadtgeschichte, IV, Neuzeit:
1794–1918*, Cologne, 1960, p. 76 (Source:
Kölnische Zeitung, no. 241, 31 August 1861)

Dortmund

UWE BITZEL, *Damit kein Gras darüber wächst.
Ereignisse um die Reichspogromnacht 1938 in
Dortmund*, eds. Gesellschaft für christlich-jüdische
Zusammenarbeit and Stadtarchiv Dortmund,
Dortmund, 1988

GESCHE FÜRSTENAU, *Architekt im preußischen
Staatsdienst: Eduard Fürstenau (1862–1938) und
seine Sakralbauten*, Master Thesis,
Frankfurt/Main, 1988

Die Synagoge in Dortmund, in: *Beiträge zur
Geschichte Dortmunds und der Grafstadt Mark*,
vol. 80, p. 65–87

WERNER HABEL, *Die Zerstörung der Dortmunder
Synagoge im Jahre 1938*, in: *Judenfeindschaft in
Altertum, Mittelalter und Neuzeit*, Königstein/
Taunus, 1981, p. 113–142

ULRICH KNIPPING, *Die Geschichte der Juden in
Dortmund während des Dritten Reiches*,
ed. Historischer Verein, Dortmund, 1977

JAKOB LOEWENBURG, *Die Einweihung der neuen
Synagoge in Dortmund (1900)*, in: *Aus Geschichte
und Leben der Juden in Westfalen*, ed. Hans C.
Meyer, Frankfurt/Main, 1962, p. 81–87

Dresden

ROBERT BRUCK, *Gottfried Semper*, in:
Der Baumeister, vol. 1, no. 8, 1903, p. 85–86

ADOLF DIAMANT, *Chronik der Juden in Dresden*,
Darmstadt, 1973

HELMUT ESCHWEGE, *Fremd unter meinesgleichen.
Erinnerungen eines Dresdner Juden*, Berlin 1991

MARTIN FRÖHLICH, *Gottfried Semper. Zeichneri-
scher Nachlaß im Besitz der E.T.H. Zurich*, Basle,
Stuttgart, 1974, cat.no. 99-1-1 to 4, p.74–75,

Gottfried Semper, Zurich, 1991

CORNELIUS GURLITT, *Beschreibende Darstellung
der älteren Bau- und Kunstdenkmäler des König-
reichs Sachsen*, issue 21–23, Dresden, 1903, p. 296

HAROLD HAMMER-SCHENK, *Synagogen in Deutsch-
land: Geschichte einer Baugattung im
19. und 20. Jahrhundert*, in: *Hamburger Beiträge
zur Geschichte der deutschen Juden 8*,
Hamburg, 1981, p. 308–347

EMIL LEHMANN, *Aus alten Acten. Bilder aus der
Entstehungsgeschichte der Israelitischen Religions-
gemeinde zu Dresden*, Dresden, 1886

A. LÉVY, *Notes sur l'histoire des juifs de Saxe*, in:
Revue des études juives XXV, 1892, p. 217–234

FRITZ LÖFFLER, *Das alte Dresden. Geschichte und
Bauten*, 5th ed., Frankfurt/Main, 1966, p. 136, 377

HELEN ROSENAU, *Gottfried Semper and the Ger-
man Synagogue Architecture*, in: *Leo Baeck
Institute Year Book XXII*, 1977, p. 237–244

HANS SEMPER, *Gottfried Semper. Ein Bild seines
Lebens und Wirkens*, Berlin, 1880, p. 14

Die Synagoge in Dresden, in: *Allgemeine
Bauzeitung XII*, 1847, p. 127, plate no. 105–07

*Zwischen Integration und Vernichtung. Jüdisches
Leben in Dresden im 19. und 20. Jahrhundert*, in:
Dresdner Hefte. Beiträge zur Kulturgeschichte, vol.
14, 1996, issue 45,1

Frankfurt

PAUL ARNSBERG, *Bilder aus dem jüdischen Leben im alten Frankfurt*, Frankfurt / Main, 1970

Die jüdischen Gemeinden in Hessen. Anfang, Untergang, Neubeginn, 3 vols, Frankfurt / Main, 1972–1975

Neunhundert Jahre Muttergemeinde Israel, Frankfurt am Main 1074–1974, Frankfurt / Main, 1974

Die Geschichte der Frankfurter Juden seit der Französischen Revolution, vol. 2, Darmstadt 1983, p. 21–43

Berliner Architekturwelt IX, 1907, p.167–168

LUDWIG BERNOULLY, *Die neue Synagoge in Frankfurt am Main, Friedberger Anlage*, in: *Der Baumeister VI*, issue 2, 1907, p. 13–20

FRANK BLECHEN, *Die Synagoge an der Friedberger Anlage: Gedenkstätte für die ehemalige Synagoge an der Israelitischen Religionsgemeinschaft*, ed. Garten und Friedhofsamt, Frankfurt / Main, without year specification

DEUTSCHE BAUZEITUNG XI, 1906, p. 538

HAROLD HAMMER-SCHENK, *Synagogen in Deutschland: Geschichte einer Baugattung im 19. und 20. Jahrhundert*, in: *Hamburger Beiträge zur Geschichte der deutschen Juden 8*, Hamburg, 1981, p. 117–118, 462–465

J. HOFFMANN AND A. REINMANN, *Frankfurt und seine Bauten*, Frankfurt / Main, 1886

ROLAND JAEGER (ed.), *Robert Friedmann*, Berlin, 2000

JÜDISCHE GEMEINDE FRANKFURT AM MAIN, *Materialien zum 40. Jahrestag der Synagogenzerstörung in Hessen*, Frankfurt / Main, 1979

MANFRED KOOB, *Jüdische Sakralbauten: 3D CAD Visualisierung des Zerstörten; student works of the Department CAD in Architecture*, exhibition "Fragmente und Rekonstruktion", Museum Judengasse, Darmstadt, 1996

HANS OTTO SCHEMBS, *Der Börneplatz in Frankfurt am Main – ein Spiegelbild jüdischer Geschichte*, Frankfurt / Main, 1987

ZENTRALBLATT DER BAUVERWALTUNG XXIV, 1904, p. 319, 420

Hanover

PETER EILITZ, *Leben und Werk des königlich-hannoveranischen Baurates Edwin Oppler*, in: *Hannoversche Geschichtsblätter no. 25*, 1971, issue 3–4, p. 127–310, (especially p. 135–136, 164–167)

HAROLD HAMMER-SCHENK, *Edwin Opplers Theorie des Synagogenbaus. Emanzipationsversuche durch Architektur*, in: *Hannoversche Geschichtsblätter no. 32*, 1979, p. 101–13

JEWISH CHRONICLE, July 23 1865, London

LANDESHAUPTSTADT HANNOVER (ed.), *Leben und Schicksal. Zur Einweihung der Synagoge in Hannover*, Hanover, 1963

LUDWIG LAZARUS, *Die Synagoge zu Hannover*, in: *Mitteilungen der Kulturvereine in Hannover XXXIII*, November 1958, p. 1–4

PETER SCHULZE, *Juden in Hannover. Beiträge zur Geschichte und Kultur einer Minderheit*, Hanover, 1989

Kaiserslautern

HEINZ FRIEDEL, *Die Juden in Kaiserslautern*, in: *Pfälzer Heimat 19*, issue 2, 1968, p. 55–58

HEINZ FRIEDEL, *Aus der Geschichte der Kaiserslauterer Judengemeinde*, in: Pfälzer Heimat 27, 1976, p. 99–103

FRANZ-JOSEF ZIWES (ed.), *Badische Synagogen aus der Zeit von Friedrich I. in zeitgenössischen Photographien*, Karlsruhe, 1997

Leipzig

ADOLF DIAMANT, *Chronik der Juden in Leipzig. Aufstieg, Vernichtung und Neuanfang*, Chemnitz, 1993

EPHRAIM CARLEBACH STIFTUNG (ed.), *Judaica Lipsiensia. Zur Geschichte der Juden in Leipzig*, Leipzig, 1994

HAROLD HAMMER-SCHENK, *Synagogen in Deutschland: Geschichte einer Baugattung im 19. und 20. Jahrhundert*, in: *Hamburger Beiträge zur Geschichte der deutschen Juden 8*, Hamburg, 1981, p. 265–275

SIMSON JAKOB KREUTNER, *Mein Leipzig. Gedenken an die Juden meiner Stadt*, Leipzig, 1992

LEIPZIGER STADTARCHIV: Bauakte 4979. Verkehrs- und Feuersicherheiten

LEIPZIGER STADTARCHIV: Bauakte 5254. Baupolizeisachen

Der neue israelitische Tempel in Leipzig. Von der Grundsteinlegung bis zur Vollendung des Baues, Leipzig, 1855

HANS-PETER SCHWARZ (ed.) et al., *Die Architektur der Synagoge*, exhibition catalogue, Deutsches Architekturmuseum Frankfurt / Main, Stuttgart, 1988

VEREINIGUNG LEIPZIGER ARCHITEKTEN UND INGENIEURE (ed.), *Leipzig und seine Bauten*, Leipzig, 1892

VORSTAND DER ISRAELITISCHEN RELIGIONSGEMEINSCHAFT LEIPZIG (ed.), *Aus Geschichte und Leben der Juden in Leipzig, Festschrift zum 75jährigen Bestehen der Leipziger Gemeindesynagoge*, Leipzig, 1930

Mannheim

VOLKER KELLER, *Jüdisches Leben in Mannheim*, Mannheim, 1992

JÜDISCHES GEMEINDEZENTRUM MANNHEIM F3, *Festschrift*, Mannheim, 1987

KARL OTTO WATZINGER, *Geschichte der Juden in Mannheim 1650–1945*, Stuttgart, 1987

Munich

LEO BAERWALD, *Festpredigt zum 50jährigen Jubiläum der Synagoge in München (1887–1937)*, Munich, 1937

DOUGLAS BOKOVOY AND STEFAN MEINING (eds.), *Versagte Heimat: jüdisches Leben in Münchens Isarvorstadt, 1914–1945*, Munich, 1994

BERNWARD DENEKE (ed.), *Siehe, der Stein schreit aus der Mauer. Geschichte und Kultur der Juden in Bayern*, exhibiton catalogue, Germanisches Nationalmuseum, Nuremberg, 1988

SAL FROST (ed.), *Hauptsynagoge München 1887–1938. Eine Gedenkschrift mit einem historischen Rückblick von Wolfram Selig*, Munich, 1987

YVONNE GLEIBS, *Juden im kulturellen und wirtschaftlichen Leben Münchens in der zweiten Hälfte des 19. Jahrhunderts*, in: *Neue Schriftenreihe des Stadtarchivs München (Miscellanea Bavarica Monacensia 76)*, Munich, 1981

ANDREAS HEUSLER and TOBIAS WEGER, *Kristallnacht. Gewalt gegen Münchner Juden im November 1938*, Munich, 1998

JÜDISCHES MUSEUM MÜNCHEN (ed.), *Beth ka-Knesseth. Ort der Zusammenkunft. Zur Geschichte der Münchner Synagogen, ihrer Rabbiner und Kantoren*, exhibition catalogue, Jüdisches Museum München, Munich, 1999

URSULA VON KARDOFF, *Juden in München. Die Entwurzelten*, in: *Zeitschrift zum Verständnis des Judentums*, Munich vol. 15, 1976, issue 57, p. 6732–6736

EMANUEL KIRSCHNER, *Abschied von der Münchner Hauptsynagoge*, in: *Von Juden in München*, ed. HANS LAMM, Munich, 1958, p. 348

HANS LAMM, *Die Geschichte der Münchner Hauptsynagoge (1887–1938)*, in: *Münchner Israelitische Gemeindezeitung*, September 1981, p. 6–9

HANS LAMM, *Von Juden in München*, Munich, 1958

HANS LAMM, *Vergangene Tage. Jüdische Kultur in München*, Munich, 1982

JOSEPH PERLES, *Reden zum Abschiede von der alten und zur Einweihung der neuen Synagoge in München am 10. und 16. September 1887*, Munich, 1887

ALBERT SCHMIDT, *Entwurf einer Synagoge für München*, in: *Zeitschrift für Baukunde 1*, 1878, issue 4, pp. 487

ALBERT SCHMIDT, *Entwurf einer Synagoge in München mit einer Beschreibung der Entstehungsgeschichte und des Baus von K.E.O. Fritsch*, Munich, 1889

HANS-PETER SCHWARZ (ed.) et al., *Die Architektur der Synagoge, exhibition catalogue*, Deutsches Architekturmuseum Frankfurt/Main, Stuttgart, 1988

WOLFRAM SELIG, *Hauptsynagoge München 1887–1938*, Munich, 1987

WOLFRAM SELIG, *Synagogen und jüdische Friedhöfe in München*, Munich, 1988

Nuremberg

MAX FREUDENTHAL, *Die Israelitische Kultusgemeinde Nürnberg, 1874–1924*, Nuremberg, 1925

MORITZ LEVIN, *Die Berechtigung des Gotteshauses. Weiherede, gehalten bei der Einweihung der neuen Synagoge zu Nürnberg am 08. September 1874*, Nuremberg, 1874

ARND MÜLLER, *Geschichte der Juden zu Nürnberg, 1146–1945*, in: *Beiträge zur Geschichte und Kultur der Stadt Nürnberg 12*, Nuremberg, 1968

KARL OTTO WATZINGER: *Geschichte der Juden in Mannheim 1650–1945*, Stuttgart, 1987

Plauen

ADOLF DIAMANT, *Chronik der Juden in Dresden*, Darmstadt, 1973, p. 150–151

W. GOLDBERG and ADOLPH BERLINER, *Blätter der Erinnerung an die Weihe der Synagoge Plauen im Vogtland*, Plauen, 1930

HAROLD HAMMER-SCHENK, *Synagogen in Deutschland: Geschichte einer Baugattung im 19. und 20. Jahrhundert*, in: *Hamburger Beiträge zur Geschichte der deutschen Juden 8*, Hamburg, 1981, p. 532–534, 651, notes 1108 and 1137–1139

Israelitischen Gemeindehaus mit Synagoge in Plauen im Vogtland, in: *Baugilde, No. 7*, 1932, p. 359–360

F. LANDAUER, *Jüdische Kultbauten von heute*, in: *Central-Vereinzeitung X*, No. 27, 03 July 1931, p. 341–342

GERD NAUMANN, *Plauen im Vogtland, 1933–1945*, ed. CURT RÖDER, Plauen, 1996

Illustration Credits

p. 4 top
Synagogue Leipzig, lithography,1854/55, Stadt-geschichtliches Museum Leipzig

p. 4 bottom
Synagogue Cologne, water colour by Carl Emanuel Conrad, 1869, Rheinisches Bildarchiv der Stadt Köln

p. 5 top
Synagogue Kaiserslautern, Stadtarchiv Kaiserslautern

p. 5 bottom left
Synagogue Nuremberg, Stadtarchiv Nürnberg, A 41/LR-653/14

p. 5 bottom right
Synagogue Frankfurt/Main (Judengasse), Institut für Stadtgeschichte Frankfurt/Main

p. 6
Synagogue Mannheim, Stadtarchiv Mannheim, Bildsammlung, Kleinformate, Nr. 10259

p. 7 top
Synagogue Hanover, Stadtarchiv Hannover, Nachlaß Oppler, Synagoge Hannover, Foto 1.1, Mappe 13

p. 7 middle
Synagogue Dresden, Sächsische Landesbibliothek – Staats- und Universitätsbibliothek Dresden, Abt. Deutsche Fotothek

p. 7 bottom
Synagogue Munich, Stadtarchiv München

p. 8 top
Synagogue Plauen, "Blätter der Erinnerung an die Weihe der Synagoge Plauen i.V.", Plauen, 1930, Stadtarchiv Plauen

p. 8 middle
Synagogue Berlin, Landesarchiv Berlin

p. 8 bottom
Synagogue Dortmund, Stadtarchiv Dortmund

p. 9 top
Synagogue Frankfurt/Main (Börneplatz), Institut für Stadtgeschichte Frankfurt/Main

p. 9 bottom
Synagogue Frankfurt/Main (Friedberger Anlage), Blätter für Architektur und Kunsthandwerk 21, 1908, Tafel 109

p. 10 top
Synagogue Nuremberg, Essenweinstrasse, Stadtarchiv Nürnberg

p. 10 middle left
Synagogue Hanover, Historisches Museum Hannover

p. 10 middle right
Synagogue Kaiserslautern, Stadtarchiv Kaiserslautern

p. 10 bottom
Synagogue Berlin, Landesarchiv Berlin

p. 11 top
Synagogue Kaiserslautern, Stadtarchiv Kaiserslautern

p. 11 bottom
Synagogue Frankfurt/Main (Börneplatz), Institut für Stadtgeschichte Frankfurt/Main

p. 21 top above and below
The Temple of Solomon in Jerusalem, Hochschule für Jüdische Studien, Heidelberg

p. 21 middle
The Israel Museum, Jerusalem. The Menorah is the property of the IAA (Israel Antiquities Authority)

p. 21 bottom left
Synagogue in Kefar Nahum (Kapernaum), Hochschule für Jüdische Studien, Heidelberg

p. 21 bottom middle
Synagogue in Beth Alpha, Hochschule für Jüdische Studien, Heidelberg

p. 21 bottom right
Heinrich Kohl/Carl Watzinger, Die antiken Synagogen in Galiläa. Leipzig, 1916

p. 22 left
Synagogue Worms, Neg. Nr: M 10351, Stadtarchiv Worms

p. 22 middle
Drawing from 1942 of the former synagogue in Lengfeld/Odenwald (18th century), artist unknown. In: Paul Arnsberg: Jüdische Gemeinden in Hessen. Anfang, Untergang, Neubeginn. Frankfurt/Main, 1972–1975.

p. 22 right
Synagogue Ansbach, 1744–46. In: Harold Hammer-Schenk: Synagogen in Deutschland. Geschichte einer Baugattung im 19. und 20. Jahrhundert (Hamburger Beiträge zur Geschichte der deutschen Juden, vol. VIII/part II), Christians Verlag, Hamburg, 1981

p. 23 bottom
Synagogue Karlsruhe, Generallandesarchiv Karlsruhe (J-B Karlsruhe/192)

p. 32 left
Synagogue Nuremberg, Stadtarchiv Nürnberg, A 39/D-102/III

p. 32 right
Synagogue Nuremberg, Stadtarchiv Nürnberg, C 20/V 3851/BL. 84c

p. 33 top
Synagogue Nuremberg, Stadtarchiv Nürnberg, C 20/V 3851/BL. 126

p. 33 bottom
Synagogue Nuremberg, Stadtarchiv Nürnberg, C 20/V 3851/BL. 14

p. 38 left and right (detail)
Synagogue Nuremberg, Stadtarchiv Nürnberg, A 47/KS-24/VIII

p. 149
Map number 316 "Jews murdered between 1 September 1939 and 8 May 1945: An estimate", in: Atlas of the Holocaust by Martin Gilbert, p. 244 © A.P. Watt Ltd., London

© Computer-generated images
Darmstadt University of Technology, Department CAD in Architecture, Manfred Koob

Locations of synagogues and Jewish houses of worship within the German Reich before 1939 (page 12–13) collected by Meier Schwarz, Synagogue Memorial, Jerusalem, Israel. Up dates and historic material are appreciated.

Despite intensive research efforts it was not possible to identify the copyright holders in all cases. Justifiable claims will be honored within the parameters of the customary agreements.

Imprint

Synagogues in Germany
A Virtual Reconstruction
An Exhibition of the Darmstadt University
of Technology/Department CAD in Architecture
(Technische Universität Darmstadt / Fachgebiet CAD
in der Architektur), Manfred Koob, Darmstadt and the
Art and Exhibition Hall of the Federal Republic
of Germany (Kunst- und Ausstellungshalle der
Bundesrepublik Deutschland), Bonn realized by the
Institute for Foreign Cultural Relations (Institut für
Auslandsbeziehungen e.V. / ifa), Stuttgart.

Concept, Selection of Exhibits
Marc Grellert, Manfred Koob, Agnieszka Lulinska

Responsible for Institute for
Foreign Cultural Relations
Ursula Zeller

Coordination, Organisation, Editing
Marie Ani Eskenian

Catalogue Texts and Bibliography
Marc Grellert, Manfred Koob, Salomon Korn,
Agnieszka Lulinska, Stefan Wirtz

Translation of Catalogue Texts
Helga Grellert, Frankfurt/Main
Helga Schier, Santa Monica, CA

Catalogue Design
Michael Bender, Miriam Lebok
Konzept + Gestaltung, Darmstadt

Touring Exhibition Design
John Berg, Michael Staab

Touring Exhibition Panel Design
Michael Bender
Konzept + Gestaltung, Darmstadt

Design of the Photographic Mural
Michael Bender, based on design by
Regina Freymann

Exhibition Panel Texts
Stefan Wirtz, Agnieszka Lulinska, David Kessler

Documentary
Realization by Bernhard Pfletschinger
Production: Art and Exhibition Hall of the Federal
Republic of Germany, Bonn

Realization of the Computer Reconstruction
Darmstadt University of Technology
Department CAD in Architecture, Manfred Koob

Project Management
Marc Grellert, Manfred Koob

Tutors
Andreas Kreutz, Marc Möller, Philipp Putschbach

Research Assistants
Petra Lenschow, Thomas Raab, Philipp Vogt

Academic Consulting and Monitoring of the
Overall Project
Salomon Korn

Introductory Course to Art History
Darmstadt University of Technology
Art History Department
(Technische Universität Darmstadt,
Fachgebiet Kunstgeschichte), Wolfgang Liebenwein

Virtual Reconstructions, Research, Texts on
Synagogues
Students of the Darmstadt University of Technology
Department CAD in Architecture, Manfred Koob

Berlin: Birgit C. Kautz, Léontine Meijer,
Ulrich G. Winkler

Cologne: Constantin Ehrenstein, Astrid Fleckenstein,
Daniel Weickenmeier, Zoé Zimmermann

Dortmund: Maria Heck, Samad Sakkaki,
Jörg Sebastiani

Dresden: Eva Leonardi, Eva Schwarz

Frankfurt/Main: Daniela Borowicz, Peter Gallenz,
Marc Grellert, Joachim Merk, Nadine Paraton,
Patricia Sauerwein

Hanover: Johannes Cherdron, Marko Helfmann,
Carolin Oetzel, Bernd Reiners, Christian Riescher

Kaiserslautern: Daniela Georgescu, Adrian Mnich,
Heidrun Rau, Alexander Schmid

Leipzig: Kirstin Fried, Christina Stiel, Nicole Troesch

Mannheim: Niclas Brand, Helman Djaja, Egon Heller,
Andreas Kreutz, Almut Overmeier;
(Architectura Virtualis), Text: David Kessler,
Jewish Congregation of Mannheim

Munich: Alexander Löhr, Reinhard Munzel,
Thomas Raab, Timm Schwiersch

Nuremberg: Florian Guntrum, Corinna Igel,
Markus Knapp, Stephanie Wolf

Plauen: Camillo Braun, Marcin Kaminski,
Manfred Pawlowski, Olaf Reuffurth

Due to the continuing work on the 3D CAD recon-
structions by students of the Darmstadt University
of Technology, the synagogues presented here are
in varying phases of their reconstruction.

CAD Film Editing
Annette Ertl, Reza Mohebbi, Thomas Mrokon,
Helko Thoma

Historical Sources and Support provided by
Baureferat der Stadt Nürnberg: Walter Anderle, Karlheinz Kubaneck

Generallandesarchiv Karlsruhe

Hochschule für Bildende Künste Dresden: Wolfgang Rother, Ulrich Schießl

Israelitische Kultusgemeinde Nürnberg: Arno Hamburger

Jüdisches Museum Frankfurt: Fritz Backhaus, Georg Heuberger, Michael Lennartz

Reiss-Engelhorn-Museum Mannheim

Stadtarchiv Dortmund: Günther Högl, Hermann Josef Bausch

Stadtarchiv Hannover: Werner Heine

Stadt Kaiserslautern: Arne Öckinghaus

Stadtarchiv Leipzig, Historisches Seminar: Josef Reinhold

Stadtarchiv Mannheim: Andreas Heusler

Stadt München, Kulturreferat: Angelika Baumann, Julian Nida-Rümelin

Stadtarchiv Plauen: Martina Röber

Software Support provided by
Alias | Wavefront GmbH

Reconstruction of the Following Synagogues Supported to Date by:
Cologne, Hanover, Plauen: Bundesministerium für Bildung und Forschung

Frankfurt: Hessischer Rundfunk, asb baudat, Fa. Merck, Fa. Henschel und Ropertz

Dortmund: Stadtarchiv Dortmund

Kaiserslautern: Stadt Kaiserslautern

Mannheim: RNF-Rhein-Neckar-Fernsehen, Mannheimer Bürgerstiftung, Heinrich Vetter, Jüdische Erinnerungsstiftung Mannheim, Haus der Geschichte – Baden-Württemberg, Stadt Mannheim, MW Energie AG, Mannheim, Rainer von Schilling, Sparkasse Rhein-Neckar-Nord, Fuchs Petrolub, Hary Fröhlich

Munich: Kulturreferat und Stadtarchiv der Stadt München

Nuremberg: Baureferat der Stadt Nürnberg

The exhibition was shown for the first time in the year 2000 in the Art and Exhibition Hall of the Federal Republic of Germany, Bonn, Germany. The exhibition was accompanied by a publication, which first published all the texts reprinted here. The project was supported by the Federal Ministry for Education and Research. (Bundesministerium für Bildung und Forschung), Berlin/Bonn, Germany.

Director
Wenzel Jacob

Project Manager
Agnieszka Lulinska

Exhibition Design in Bonn
Johann Eisele, Ellen Kloft, Claus Staniek, Thorsten Wagner

Bibliographic Information
A CIP catalogue record for this book is available from the Library of Congress, Washington D.C., USA

Deutsche Bibliothek Cataloging-in-Publication Data
Die Deutsche Bibliothek lists this publication in the Deutsche Nationalbibliografie; Detailed bibliographic data is available on the Internet at http://dnb.ddb.de.

Darmstadt University of Technology, Department CAD in Architecture, Manfred Koob, Darmstadt (Technische Universität Darmstadt, Fachgebiet CAD in der Architektur, Manfred Koob, Darmstadt)
www.cad.architektur.tu-darmstadt.de
www.synagogen.info

Art and Exhibition Hall of the Federal Republic of Germany (Kunst- und Ausstellungshalle der Bundesrepublik Deutschland), Bonn
www.kah-bonn.de

Institute for Foreign Cultural Relations (Institut für Auslandsbeziehungen e.V./ ifa), Stuttgart
www.ifa.de

and

Birkhäuser – Publishers for Architecture, P.O. Box 133, 4010 Basel, Switzerland Part of Springer Science + Business Media
www.birkhauser.ch

The softcover edition is exclusively available in museums as an accompanying exhibition catalogue, and not on sale in bookshops.

ISBN 3-7643-7030-0
This ISBN refers to the hardcover edition.

This publication is also available in a German language edition: ISBN 3-7643-7034-3

Printed in Italy

9 8 7 6 5 4 3 2 1

With Special Support by
Cultural Foundation of Deutsche Bank
Deutsche Bank Americas Foundation